Jefferson County Library
620 Cedar Avenue
Port Hadlock, WA 98339
(360) 385-6544 www.jclibrary.info

o f

MERC

DATE DUE	
2-16	
FEB 08	
	PRINTED IN U.S.A.

IMAGES
of America

MERCER ISLAND

Priscilla Ledbetter Padgett

ARCADIA
PUBLISHING

Copyright © 2013 by Priscilla Ledbetter Padgett
ISBN 978-0-7385-9956-4

Published by Arcadia Publishing
Charleston, South Carolina

Printed in the United States of America

Library of Congress Control Number: 2012951224

For all general information, please contact Arcadia Publishing:
Telephone 843-853-2070
Fax 843-853-0044
E-mail sales@arcadiapublishing.com
For customer service and orders:
Toll-Free 1-888-313-2665

Visit us on the Internet at www.arcadiapublishing.com

*To my parents, Charles and Mary Lou Ledbetter, who
always encouraged me to follow my dreams*

CONTENTS

ACKNOWLEDGMENTS

I would like to thank Rebecca Pixler, King County Archives; Phil Stairs, Puget Sound Regional Archives; Karl House, Puget Sound Maritime Historical Society; Rebecca Marr, Museum of History and Industry; Aaren Purcell, Seattle Public School Archives; Cynthia Whaley, Washington State Department of Transportation; Michael Wendt, Department of Transportation Library; Evelyn Edens, *Seattle Times*; Mercer Island School District, Sunnybeam School; Mercer Island Preschool Association; Eastside Heritage Center, the University of Washington Libraries; and Mercer Island Library.

Thanks to Tom Castor, Mercer Island Rotary Club; Frank Sorba, Veterans of Foreign Wars; Dorothy Reeck, Roanoke Inn; Judith Baxter, Covenant Church; Hunt Priest and Jackie Johnson, Emmanuel Episcopal Church; Jamie North, St. Monica's Church; Christina Campos, Congregational Church; Ruth Ann Biggers, Presbyterian Church; Gayne Phillips, Redeemer Lutheran Church; Ruth Edwards and Robert von Tobel, Eastshore Unitarian Church; Manny Cawaling, Youth Theatre Northwest; Daniela Melgar, Mercer Island High School drama program; Dorrinda Pierce, Mercer Island Country Club; Jamie Dieveney, Mercer Island Beach Club; Joy King and Paul VonDestinon, Mercerwood Shore Club; and Leslie Rubinstein, Stroum Jewish Community Center of Mercer Island.

I would also like to thank the following individuals: Thor Augustson, Jody Samson, Ruth Mary Close, Carl Lovsted, Roy Ellingsen, Lillian Gui, Anne Woodley, Chris and Dan Tabit, Marilyn O'Neill, Kim Screen, John Stewart, Steve Townsend, Dana Melick, Lanette Reh, Diana Klein, David Eck, Myer and Barbara Coval, Lori Kovarik, Roger Page, Ed Pepples, Deborah Alexander, Rich Conrad, Gavin Cree, and Mayor Bruce Bassett.

Finally, I thank Judy Gellatly, author of *Mercer Island Heritage*, and Jane Meyer Brahm, Mercer Island Historical Society, for their many contributions toward preserving our community's history. I consulted the memoir of Alfred Fleury, a longtime islander and pioneer, as well as the notes of Dorothy Brant Brazier and columnist Virginia Odgen Elliott of the *Mercer Island Reporter* for their insights into early life on the island. Many thanks to Michael Luis, author of the Arcadia book, Images of America: *Medina,* for his invaluable insights and advice. Thanks to my editor, Amy Kline, for her patience and prodding. Lastly, I thank my husband, Charles, for his love and encouragement and my sons Andrew and Matt for believing in me.

INTRODUCTION

Mercer Island, shaped like a foot with no toes, lies in the southern end of Lake Washington. East of the city of Seattle and west of the city of Bellevue, Mercer Island is conveniently sandwiched between two large metropolitan cities, yet remains relatively rural. Home to over 22,000 residents and boasting the state's top schools and acres of parkland, Mercer Island offers a bucolic life. From its earliest beginnings, Mercer Island has been a refuge from the fast-paced world around us.

In 1860, a government land survey named "Mercer's Island" for the first time. The name was later shortened to Mercer Island, reputedly named for Thomas Mercer, an early pioneer who proposed the names of Lake Washington and Lake Union during a July 4, 1854, picnic. A prominent citizen suggested that the large island in the south end of Lake Washington be named Mercer's Island, as Mercer was known to visit it quite often. Thomas was the brother of Asa Mercer, who achieved fame for bringing two groups of "Mercer Girls" to Seattle in 1864 and 1866 as eligible brides for the large number of single men. He was also the brother of Aaron, who came to Seattle with Thomas, and filed a claim on Mercer Slough in Bellevue, which today bears his name.

Thomas Mercer was friendly with the local native tribe, the Duwamish, and often hired one of them to row him over to the island in the morning and then row him back in the evening. One afternoon, Mercer was not on shore when the Native Americans came to retrieve him. Native American legend said that the island sank into the lake each night, only to rise again in the morning. Because of this, the owner of the canoe paddled home, not wishing to be there when the island sank. The next morning, Thomas Mercer was standing on shore with dry clothes; the Native American assumed that Mercer had survived the sinking of the island.

Evidence of Native American tribes on the island have been found on the south end and north end in the form of small sites that were used as temporary fishing spots. Local Indians would gather berries and prepare fish but they did not build permanent settlements because they were not comfortable staying overnight on the island. Settlement of the island by non–Native Americans began in the late 1870s.

One of the island's first settlers was Vitus Schmid, a wagon-maker's apprentice from Baden, Germany. He and John Wenzler, a cobbler from Chicago, filed a 160-acre claim on the central part of Mercer Island and built a cabin in 1876. While clearing land on their property, a large tree fell on the cabin and wrecked it. This blow was so discouraging that Wenzler returned to his cobbler's bench and Schmid returned to Chicago. In 1878, Schmid came back to Mercer Island, filed another claim, and built another cabin. He now had a wife and two sons, Victor and Conrad. A lumber company challenged his claim, and the case was in the courts for 11 years. Schmid won, received clear title, and moved his family into the cabin in 1889. He had two more children, Theresa and Caroline. In 1897, his two sons went north to the gold fields of Alaska and the Yukon, and their ship tragically sank; all onboard drowned.

Other settlers, Charles and Agnes Olds, had a much more enduring experience. They brought their children, Alla and David, to settle in 1885. Olds built a cabin, one room plus a loft, about

midway on the east shore of the island. In November 1885, the family loaded its possessions, including a goat, onto a barge at Leschi and towed it by rowboat around the north end of the island and down the east channel to the claim. The next year, they cleared the land and planted 12 varieties of apples. Olds named this place Appleton. The name still exists today, along with the apple trees. In order to reach civilization, the Olds family had to row around the north end of the island and across to Leschi, where they would beach their boat and make their way to a wagon road leading to the foot of Yesler Way. The Yesler cable railroad had yet to be built, and Washington was still a territory.

Gardner Proctor and his Indian wife, Ellen, homesteaded 160 acres on the area from the floating bridge south to SE Thirty-fourth Street and from West Mercer Way to the lakeshore. The year of Proctor's patent was 1884, though he may have filed his claim five years earlier. He built a cabin, planted an orchard, and made other improvements. Gardiner Proctor died in 1889, and Ellen returned to her people on the Black River.

Since the island was hard to get to, settlement lagged until C.C. Calkins platted the town of East Seattle. In 1891, he built a luxurious resort on the western side of the island. Pres. Benjamin Harrison (1833–1901) stayed at the hotel during his 1891 visit to Seattle, giving Calkins's venture some notoriety.

Things were looking up for Calkins, but he was hit by a rapid succession of setbacks and disasters. By 1907, the building was back in use as a summer hotel, but it burned to the ground on July 2, 1908. Its centerpiece now gone, East Seattle nevertheless thrived. Mercer Island's first church, library, post office, telephone system, and many other services took root in the community. Islanders continued to use rowboats, steamboats, and ferries to get to and from the island.

On November 10, 1923, the East Channel Bridge opened, linking Mercer Island to the east side of Lake Washington and allowed easy automobile access to the island for the first time. It was not until 1940 that the floating bridge opened, linking Seattle to Mercer Island, ending the era of waterborne travel.

Mercer Island was incorporated in 1960. Prior to incorporation, the island was governed by isolated neighborhoods and later by the North End Improvement Club, the Mercer Island Community Club, and the South End Improvement Club. The direct governing body was the King County Commissioners. When large issues were at stake, such as roads, ferries, or bridges, the island's clubs came together in unified support. In 1970, the clubs and the Town of Mercer Island merged into the City of Mercer Island.

Since incorporation, Mercer Island has grown gradually, with roads built, schools expanded, and families moving in. The convenient location, excellent schools, and quiet charms make Mercer Island a magnet for new families of substantial means. Today, two commercial areas serve Mercer Island's residents: the Central Business District on the north end and the QFC Village on the south end. Island organizations such as the Women's Club, Rotary Club, and the Lion's Club offer friendship and service to the community.

Outstanding Islanders include Paul Allen, cofounder of Microsoft; Mary Wayte, gold medal swimmer from the 1984 Olympics; and Stanley Dunham, mother of Pres. Barack Obama.

The island's parks bustle with children and adults, and Mercer Island's Summer Celebration, held every July, gives residents and visitors alike the opportunity to shop at the craft booths and enjoy food, entertainment, and other island festivities over a three-day weekend.

This book focuses on Mercer Island mostly prior to 1980. A lot has happened since then, with the arrival of new businesses to the area such as Microsoft and Amazon. Boeing continues to be one of the region's top employers. This book will be of interest to those who wish to learn more about Mercer Island's history, culture, people, and places of interest. Through photographs, documents, maps, and other memorabilia, readers will come away with a better appreciation for Mercer Island's past and those who made Mercer Island the wonderful community it is today.

One

THE EARLY DAYS

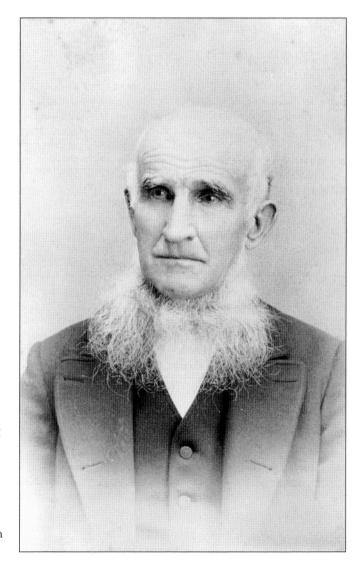

Thomas Mercer was a Seattle pioneer and Mercer Island's namesake. Thomas came to Seattle from Illinois in 1852 and is largely credited with naming Mercer Island at a picnic on his property in Seattle in 1854. He was well liked and greatly respected and was the area's first probate judge, a position he held for 10 years. (Courtesy the Museum of History and Industry.)

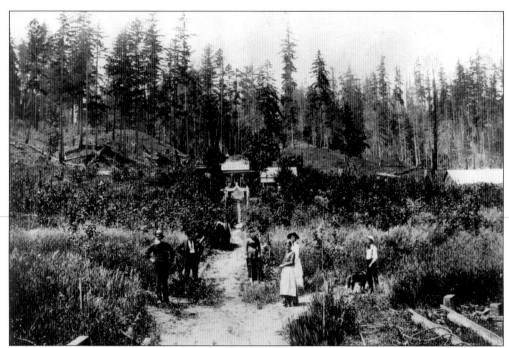

Charles Olds, left, and his family, right foreground, stood in front of their residence on the east side of Mercer Island in 1890. Those on the right were Agnes and daughter Alla (wearing a hat) and son David. The photograph was taken from the Olds lakeshore landing. Between the family and the house were the young trees of Olds's apple orchard. (Courtesy the *Seattle Times*.)

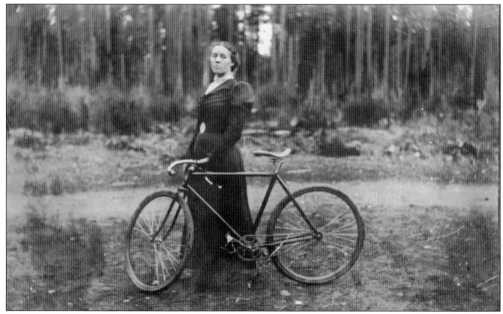

Alla Olds is pictured here with her bicycle. She was the schoolmistress in 1897, 1898, and again in 1905 and rode horseback from her home at Appleton. Her father did not believe in educating women, but Alla went to the University of Washington anyway, and her father sold her horse in retaliation. (Courtesy the Eastside Heritage Center.)

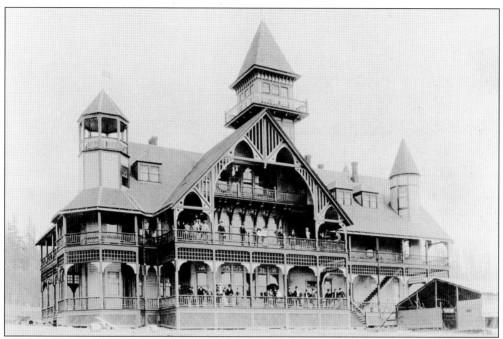

The Calkins Hotel, pictured in 1890, was named after C.C. Calkins, one of Mercer Island's first businessmen and founder of East Seattle, the neighborhood he helped plan and develop. Calkins came to Seattle in 1887 with $300 in his pocket. He platted the town of East Seattle and built the ornate hotel with wide verandas and towers. (Courtesy the Museum of History and Industry.)

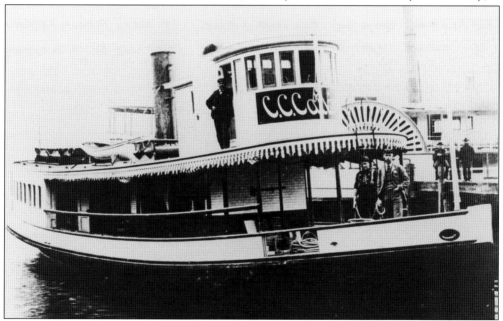

The steamer C.C. *Calkins* was built at Tayler's Mill, just south of Leschi Park, for the East Seattle Land and Development Co. of which C.C. Calkins was president. She was launched March 21, 1890, and carried passengers between Leschi and Mercer Island during the heyday of the resort from 1889 to 1893. (Courtesy the University of Washington Library.)

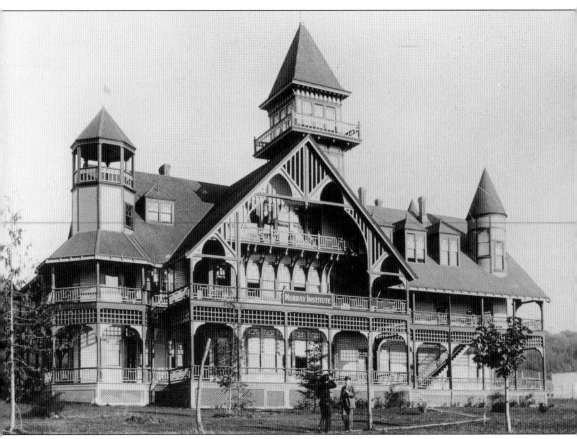

The Calkins Hotel, pictured in 1898, was sold to a group of doctors who equipped it as a sanitarium and alcoholic treatment facility. Known as the Seattle Sanitarium, it was operated until 1905 by a Dr. Murray. In 1907, the building was operated again as a summer hotel. On July 2, 1908, the building burned down. Apparently, a Japanese houseboy had resented a scolding and stuffed the chimney with greasy rags to get even; as he said, to make "a big smoke." The burning of the hotel marked the end of Calkins's dream but left the East Seattle settlement, where some of the earliest homes still stand today. East Seattle, the island's first (and for many years, the only) center of community activity, was the birthplace of many of today's activities and traditions. (Courtesy the Museum of History and Industry.)

The David Alexander residence is pictured in 1905. At that time, Mercer Island was known for forest and country roads as well as pheasants and deer. In 1903, Alexander bought his first five acres on the island for $33 at a tax title sale. A couple of years later, he built his house for $1,000 and brought his wife and children to live there. (Courtesy Puget Sound Regional Archives.)

The Alexander's house was funny, tall, narrow, yellow, red-roofed, and full of inconveniences, with five porches that hung on it like tie racks. They had a barn for the horse and cow, a chicken run, apple orchards, and a grove. They had no electricity or plumbing and used chamber pots. (Courtesy Puget Sound Regional Archives.)

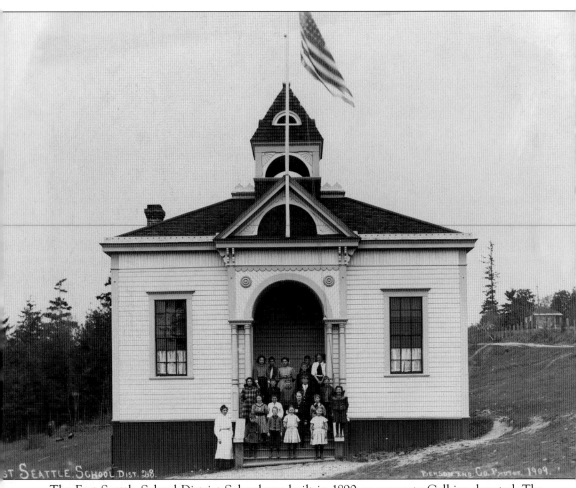

The East Seattle School District School was built in 1890 on property Calkins donated. The little white schoolhouse served faithfully for 24 years. All eight grades were taught in one room, and for a few years, the alcove in the classroom also housed a kindergarten. The building also served as a community center, church meeting place, dance hall, prizefight arena, and a polling place during elections. On election night, after all the ballots had been counted and the people had gone home, the fire left burning in the stove caused a conflagration, and the building burned down. (Courtesy the University of Washington Library.)

Standing on the steps of the little white schoolhouse in 1899, eighth-grade cousins Geno (white dress) and Ellen Sandell were part of a group photograph, including five other children and teachers Della Parker and Lena Fuller. (Courtesy the University of Washington Library.)

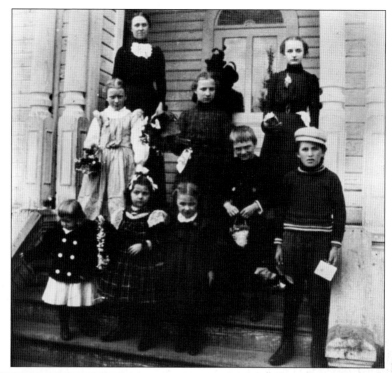

The East Seattle School was built in 1914 to serve the growing number of children in the neighborhood. At that time, Mercer Island had almost 100 pupils, most of them living in the East Seattle neighborhood. The 81 students in nine grades started school in the new building in September 1914. (Courtesy the Museum of History and Industry.)

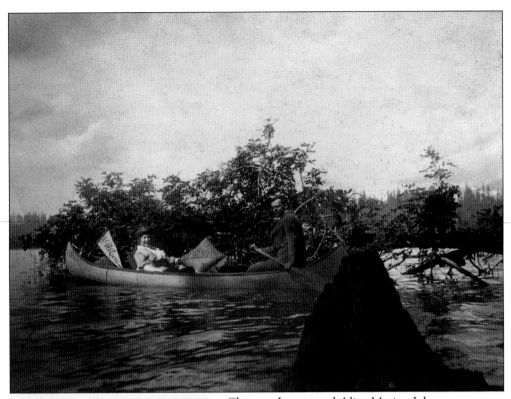

Clarence Larsen and Alice Marian Johnson, Ruth Mary's parents, are pictured in their canoe around 1915. They chose their property on Mercer Island while paddling around it in their blue canoe. They were married in 1916 in Seattle at St. Clement's Church on choir night. As they were married the Thursday after Easter, they were able to use the Easter altar flowers for the wedding. (Courtesy Ruth Mary Close.)

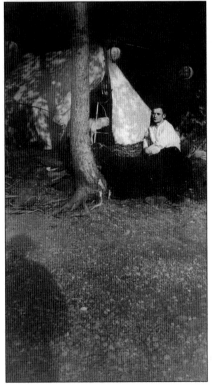

Clarence and Marian (as she preferred to be called) Larsen lived in two tents on the beach while they were building their home. Ruth Mary's father remembered how his lumber was off-loaded at the wrong dock, north of his. He floated the lumber down to his beach. Then it was hauled up the bank to the house site. (Courtesy Ruth Mary Close.)

Marian Larsen, shown here in 1916 shortly after their marriage, is tying up their canoe on the shores of Mercer Island. For cooking meals, they had a Perfection Oil Heater. The top was about 12 inches across, so she cooked one dish at a time. First, she would make the dessert, then the vegetable, and then the meat. (Courtesy Ruth Mary Close.)

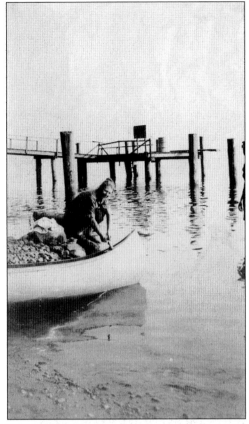

Ruth Mary (Larsen) Close is pictured with her class in 1926 on her first day at East Seattle School. She is in the second row on the far left. Ruth Mary remembers her father made a plank walk from her house to school, over a mile away, so that she could walk to school while avoiding the thick gumbo clay. (Courtesy Ruth Mary Close.)

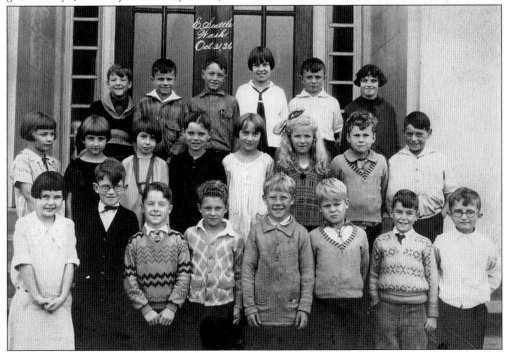

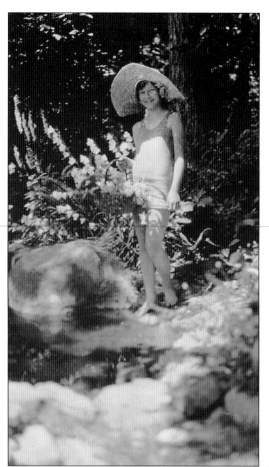

Ruth Mary (Larsen) Close is pictured holding a basket of flowers on her family's property in the mid-1920s. She and her friends enjoyed many fun activities on the island including exploring, fort building, camping out, and swimming. They would stay out on the dock all day, jumping in and out continually. (Courtesy Ruth Mary Close.)

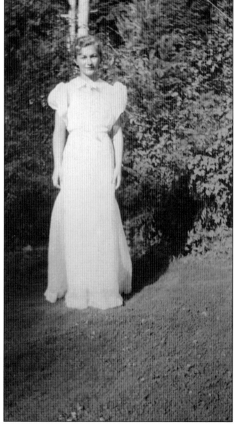

Ruth Mary (Larsen) Close is pictured around the time she attended Garfield High School in Seattle in the mid-1930s. She had to take the ferry *Dawn* to Leschi, then the cable car to Garfield. She was very shy at first but soon made many friends. She used to stay overnight with them in town occasionally, and they used to come to Mercer Island for overnights as well. (Courtesy Ruth Mary Close.)

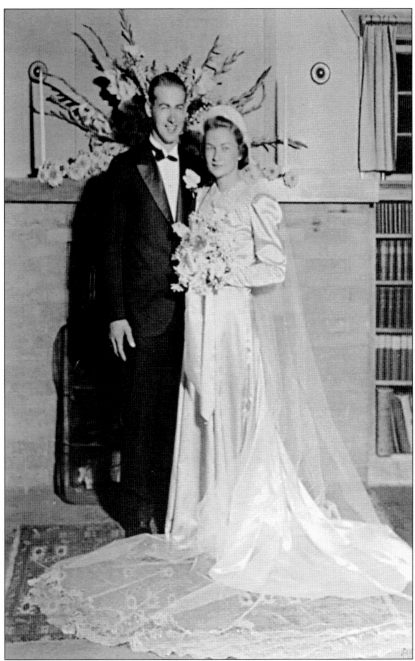

Ruth Mary Larsen and Donald Close are pictured on their wedding day, August 19, 1938, two weeks after Ruth Mary's 21st birthday. Ruth Mary and Don met on a blind date while in college. They were both college graduates. Ruth Mary majored in accounting, while her husband Donald majored in electrical engineering. They lived in a cabin on the beach at her parents' house until they were able to buy property and build on East Mercer Way. They had three children when they moved by barge around the island and into their unfinished basement. Two more children were born before they moved upstairs into their finished house, and one more child arrived seven years later. (Courtesy Ruth Mary Close.)

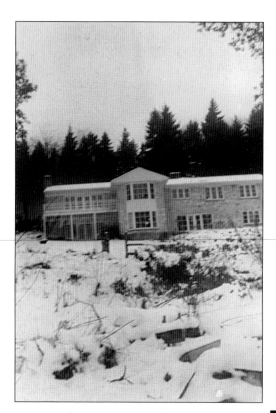

Ruth Mary and Donald Close's house on East Mercer Way is shown after a snowfall. In 1941, they purchased the property on the east side of the island and started to build a home. They moved in October 1944 when Cathy was a baby, Marilyn was two, and Dick was four. Ruth Mary went on to have three more children: David, Frank, and Christy. (Courtesy Ruth Mary Close.)

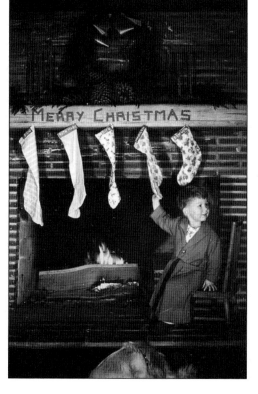

Ruth Mary and Don Close's son Dick is getting ready for Christmas in their new house. As a child, Ruth Mary dreamed of having a family of her own. Ruth Mary and Donald were blessed with six children and 10 grandchildren. Though they loved the life they built on Mercer Island, they also loved to travel and had houses in Tofino, British Columbia, and on Whidbey Island. (Courtesy Ruth Mary Close.)

Donald Close is holding his baby daughter Marilyn in 1942. Donald Close received his degree in electrical engineering from the University of Washington in 1937. In 1939, he became engineer in charge and, in 1941, received his professional engineer's license for the State of Washington. (Courtesy Ruth Mary Close.)

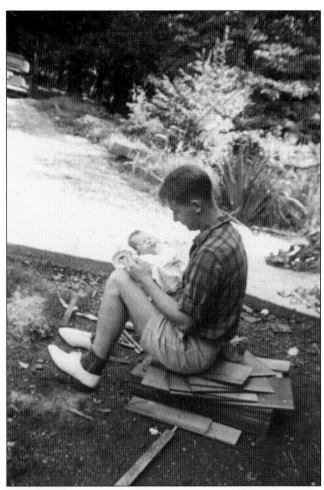

Donald and his daughter Marilyn are pictured on the lawn of their new home. Early in 1947, Donald founded the Donald W. Close Company, focusing on commercial, industrial, and government electrical construction and excelling at large, complex projects. His company worked on two floating bridges: the Hood Canal Bridge and the Lake Washington Bridge. (Courtesy Ruth Mary Close.)

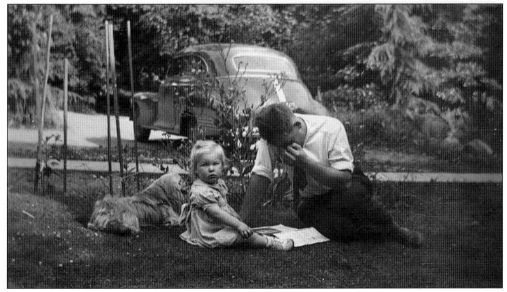

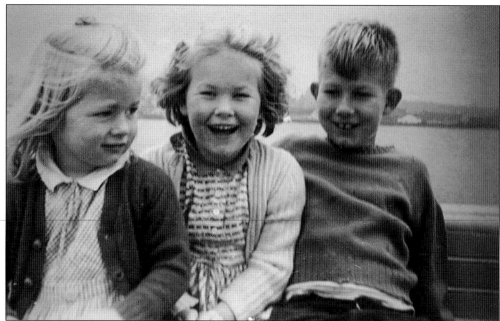

Cathy, Marilyn, and Dick Close are pictured from left to right in this photograph from the mid-1940s. Their new home on East Mercer Way had a beautiful lawn and garden. Highlights were the rope swing, sandy cove, and a dock, which later included a diving board and slide. Various boats and a homemade water-ski jump were moored at the dock for several years. (Courtesy Ruth Mary Close.)

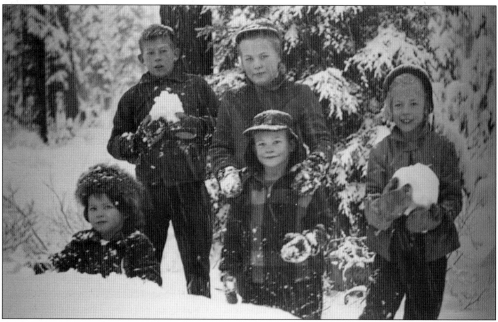

Dick, Marilyn, Cathy, David, and Frank Close are pictured from left to right enjoying a rare snowfall on the island. Don and Ruth Mary believed in hard work, and the Close kids all did their share of manual labor around the house. Every Saturday, there was a new list of chores for each child to finish before they could play. (Courtesy Ruth Mary Close.)

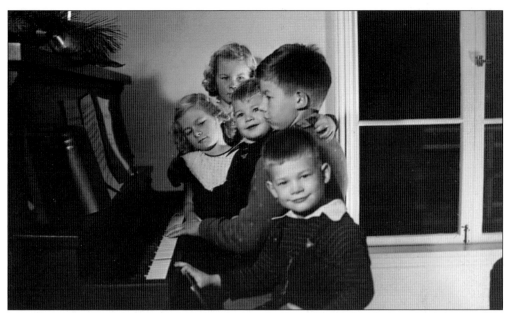

Marilyn, Cathy, David, Dick, and Frank Close are pictured from left to right around the piano in this photograph from the mid-1940s. The family enjoyed many trips together, including five trips to Hawaii. They also enjoyed their family vacations in Tofino, British Columbia, and Whidbey Island, Washington, where the family purchased their own property in the 1950s. (Courtesy Ruth Mary Close.)

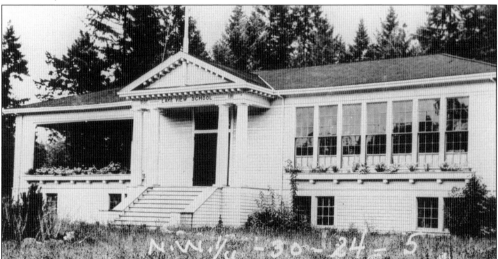

In 1918, the local school district voted to build a schoolhouse by issuing local improvement bonds. The Lakeview School was built on the south end of Mercer Island, and grades one through eight were taught there until 1941, when enrollment dropped, and roads had been improved enough to bus students to East Seattle School. The first teacher was Lucy Furness. The first graduating class was in 1920. In 1957, after kindergarten classes had permanently moved to the newly constructed Lakeridge School, Nuky Fellows and Eleanor Wolf were hired to teach preschool classes. Lakeview's original building still stands today, known as Sunnybeam School, a preschool for ages four through six. In 1988, the building was listed in the National Register of Historic Places. (Courtesy Sunnybeam School.)

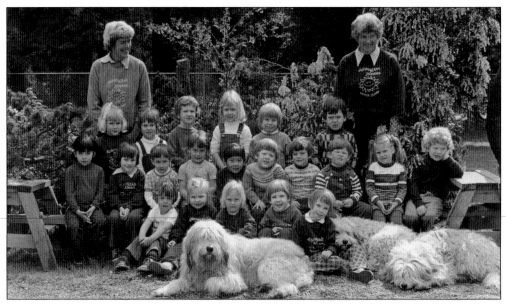

Sunnybeam School preschoolers and their teachers and dogs are depicted in this 1975 photograph. Teachers Eleanor Wolf (left) and Nuky Fellows (right) opened Sunnybeam School in 1972, after working for the Mercer Island Nursery School Association, now Mercer Island Preschool Association (MIPA), since 1957. (Courtesy Sunnybeam School.)

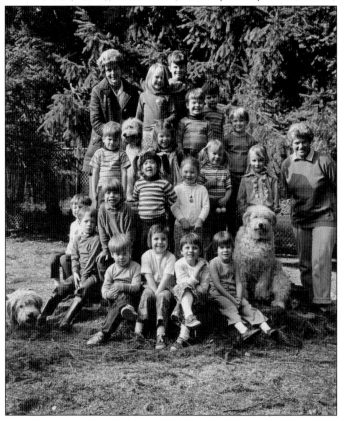

Another preschool class is depicted here, this one from 1965. Eleanor Wolf passed away in 1981, as did Nuky Fellows in 2008. Preschool parents operate the school with a dedicated volunteer board, and it continues to run successfully as a nonprofit, tax-exempt organization. In 1964, the Mercer Island Club and the south end Improvement Club incorporated under the name Mercer Island Community Club. In 1974, the club changed its name to Pioneer Park Youth Club, which owns and manages the Sunnybeam School, Mercer Island Saddle Club, the Children's Dance Conservatory, and Teddy Bear Camp. (Courtesy Sunnybeam School.)

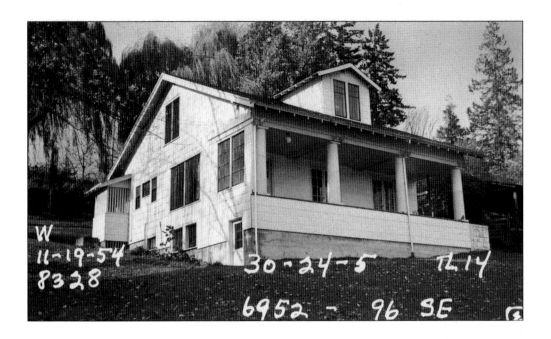

The Samson family home, located on the south end of the island, was built in 1916. It was home to the Stansbury family for many years, and they raised five children there. Howard Stansbury was school board chairman in 1951, the year the deeds were signed by the school board for a new school site on the south end of the island. Two schools were built on the 10-acre tract: Lakeridge Elementary and Islander Middle School, formerly South Mercer Junior High. The Stansburys lived in the home during the 1950s and 1960s. The home was occupied by the Brindley family prior to the Samsons. (Both, courtesy Jody and Dan Samson.)

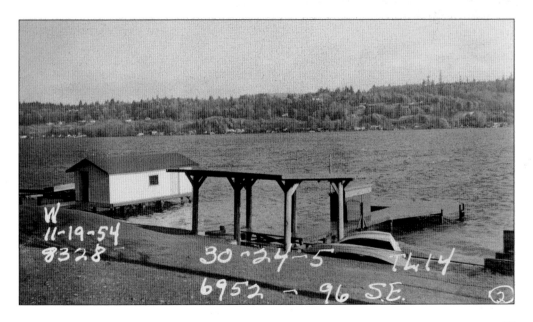

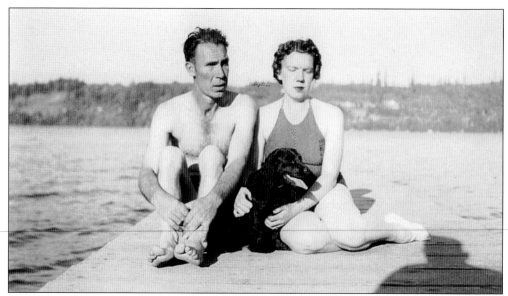

Thor Augustson's parents, Knute and Eunice Augustson, sit on the dock at the North Star Property on the east side of the island. The property was purchased in 1926 and sold to the Good Templars Association, of which the Augustsons were members. The seven-acre property consisted of 13 cabins, a pavilion with kitchen and hall, dock with swimming area, picnic tables, and several out buildings. (Courtesy Thor Augustson.)

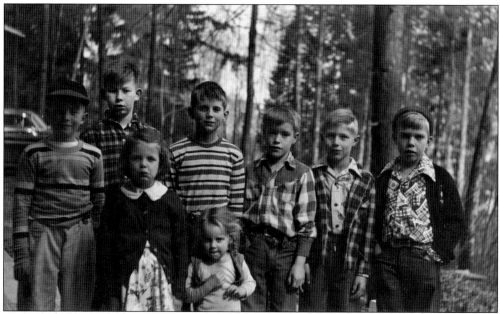

Knute and Eunice Augustson's son Thor (far right) is pictured with neighborhood friends on the east side of the island. Thor attended Sunnybeam School for kindergarten, then the East Seattle School for grades one to eight. For high school, he attended Mercer Island High School, graduating in 1960. (Courtesy Thor Augustson.)

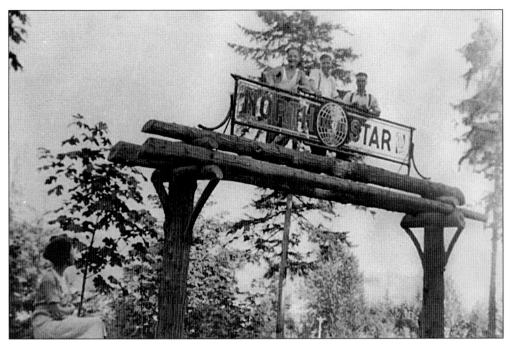

Standing on the North Star sign along East Mercer Way in the late 1920s are, from left to right, Alvin, Bert, and Arnie Hagg. The International Order of Good Templars was founded on the principles of total abstinence from alcoholic beverages, education of mankind, democracy, equality of race, sex, religion, and political views, international brotherhood, and world peace. Today, Good Templars are found in 45 countries and five continents. (Courtesy Thor Augustson.)

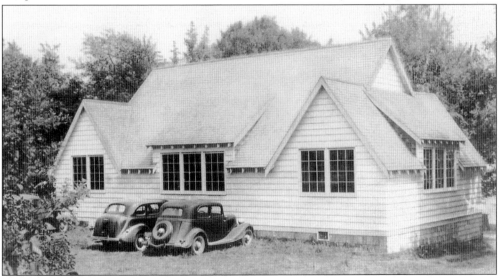

The North Star Pavilion, as seen in 1938, served as a community center for the Good Templars Association of Seattle. The decision to form such an organization was led by a group of Swedish immigrants who were interested in having their own temperance lodge. Many of them were raised in a lodge in Sweden, their homeland, and being in a new land, they looked forward to a place where they could gather together with friends and family, speak their language, and learn to be American citizens. (Courtesy Thor Augustson.)

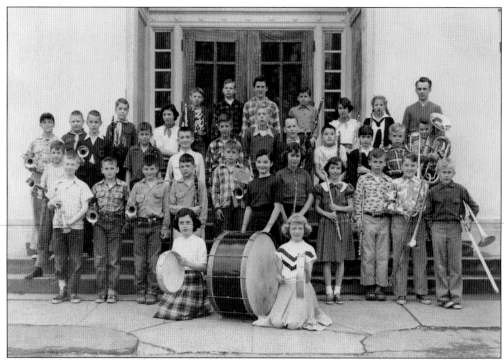

Thor Augustson is pictured with his class at the East Seattle School in 1952. The students were getting ready to practice their instruments. Thor is on the far right side holding his trombone. The building served as a school until 1970 and later housed the Mercer Island Boys and Girls Club, as well as a preschool co-op. (Courtesy Thor Augustson.)

Thor Augustson is pictured with his graduating class at the East Seattle School in 1955. The school had the island's longest record of school service when it was closed in 1982. The building was later sold to the Boys and Girls Club. In the fall of 1955, Mercer Island High School opened. (Courtesy Thor Augustson.)

28

Wink King, shown here in 1942, is clearing land on his property on the east side of the island, near King's Cove. Betty Ekrem purchased four lots from Wink on the south end for $1,500 in 1940. Their home was right on the beach, with parking above and a rail trolley to get things up and down the hill. (Courtesy Roy Ellingsen.)

The Ellingsen family home is pictured here in 1940. Betty and Erling Ellingsen raised three children here. According to their son Roy, his childhood was filled with swimming in the lake, exploring the island's wide-open spaces, and drawing. "I remember thinking, even as a kid, that life here was pretty cool," commented Roy. (Courtesy Roy Ellingsen.)

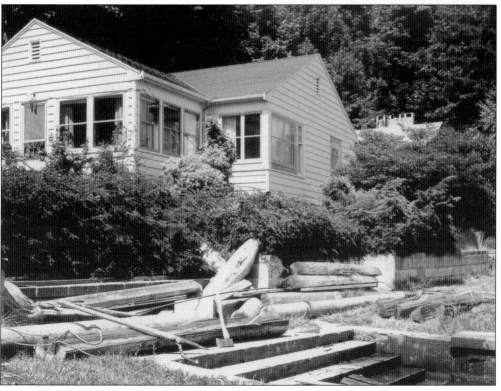

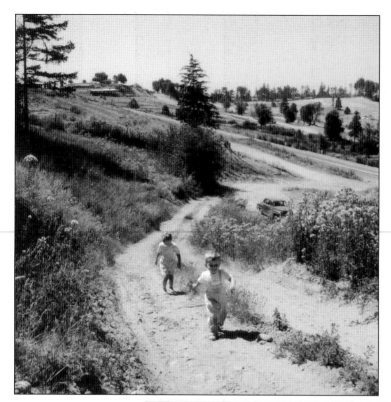

Roy Ellingsen and his brother Ken Ellingsen are shown running up what is now Island Crest Way. The family car can be seen parked in the background. Ellingsen attended school on the island and graduated in 1973 in one of the largest classes ever seen on the island. (Courtesy Roy Ellingsen.)

The Ellingsen brothers are pictured looking at what was then the downtown area of Mercer Island. This 1958 photograph shows something of the rural quality of the island, along with the new growth of the town center that was to continually expand over the years. (Courtesy Roy Ellingsen.)

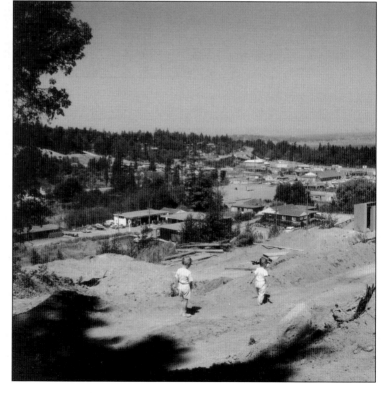

Roy's residence shared the property with the light tender *Manzanita*, which his mother Betty had purchased in 1949 and had towed to the property and brought up on the land. The tender was converted to a residence that provided extra room for the family and was often used as a guesthouse. (Courtesy Roy Ellingsen.)

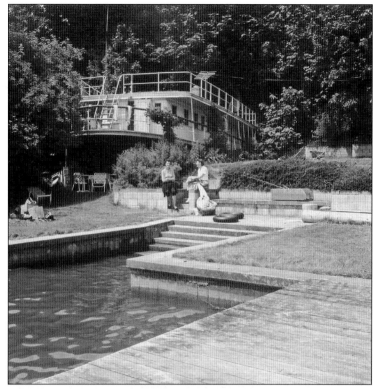

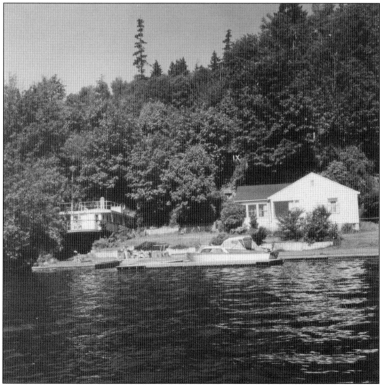

Here is the Ellingsen home and boat in 1959. In the center is the rail trolley, barely visible through the lush vegetation. The island is known for its acres of forest and parks; logging had a foothold on the island from the 1880s to the turn of the century. (Courtesy Roy Ellingsen.)

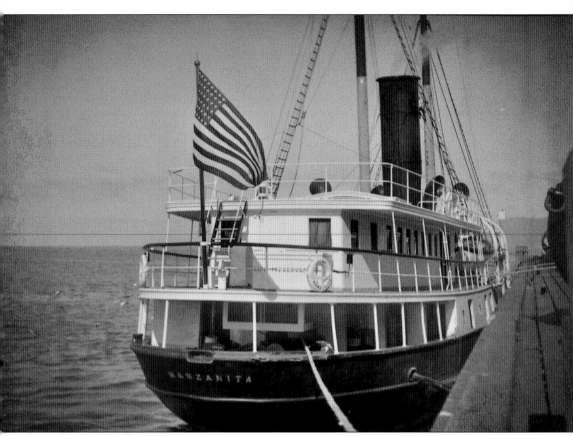

The USS *Manzanita* was built in 1906 and launched at Camden, New Jersey, in 1908. In 1917, it was transferred to the Navy, was returned to the custody of the department of commerce, and assigned to the Pacific Northwest. The *Manzanita* was later a lighthouse tender that served the lighthouses of the Oregon Coast from 1929 to 1941. Betty Ekrem purchased the stern portion (one-fifth of the entire ship) in 1949 and had it barged to Mercer Island. Betty's father, Ed Ekrem, helped her with the project. Ownership transferred from Betty Ekrem to Ed Ekrem in 1956, and in 1971, Ed Ekrem sold the boathouse to John Summers. The Tao family took possession of the boathouse in 2006. (Courtesy Lillian Giu and Laurence Tao.)

Two

FERRIES

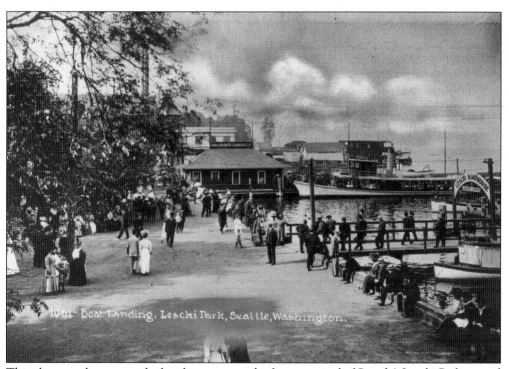

This photograph captures the bustling scene at the ferry terminal of Seattle's Leschi Park around the beginning of the 20th century. Ferries left this terminal for points around Lake Washington, including Mercer Island, several times a day. Mercer Island excursions were popular at that time. (Courtesy the *Seattle Times*.)

S. S. DAWN
EAST SEATTLE ROUTE
(MERCER ISLAND)
Summer Schedule Effective June 1, 1936

Lv. Seattle Leschi Park	Lv. Mercer Heights	Lv. East Seattle
Daily Except Sundays and Holidays		
*6:25 A.M.	6:55 A.M.	7:10 A.M.
*7:25 A.M.	8:00 A.M.	8:15 A.M.
§9:00 A.M.	§9:45 A.M.	§10:00 A.M.
11:15 A.M.	12:00 Noon	12:15 P.M.
4:00 P.M.	4:45 P.M.	5:00 P M.
5:30 P.M.	†6:00 P.M.	5:45 P.M.
6:30 P.M.	†7:00 P.M.	6:45 P.M.
8:00 P.M.		8:15 P.M.
10:30 P.M.		10:45 P.M.
SATURDAYS ONLY		
2:30 P.M.	3:00 P.M.	3:15 P.M.
SUNDAYS AND HOLIDAYS		
9:00 A.M.	9:30 A.M.	9:45 A.M.
1:30 P.M.	2:00 P.M.	2:15 P.M.
5:30 P.M.	6:00 P.M.	6:15 P M.
8:00 P.M.		8:15 P.M.
10:30 P.M.		10:45 P.M.

*Direct to Mercer Heights †Direct to Seattle
§Omitted on Saturdays

Single Trip......$0.15 Round Trip......$0.25
10 Single Trip Commutation................. 1.00

The 8:00 and 10:30 P.M. trips make no landings south of East Seattle except upon request.

J. L. ANDERSON, Operator
Office, Leschi Park, Seattle—East 5100

This SS *Dawn* ferry schedule, effective June 1, 1936, highlights the summer schedule for the East Seattle route. Note that a one-way ticket costs 15¢, and a round-trip ticket costs 25¢. Ferries departed daily from Leschi and stopped at Mercer Heights and East Seattle. (Courtesy Ruth Mary Close.)

The steamer *Dawn*, pictured here, operated around the turn of the century until 1938. Many Mercer Island schoolchildren rode the *Dawn* to Garfield High School before the floating bridge was built. Anyone who wanted to go to town rode the *Dawn*. As Ruth Mary Close remembers, "To buy clothes and shoes and things for the house and to go to the doctor and the dentist, we went on the *Dawn*." (Courtesy the Museum of History and Industry.)

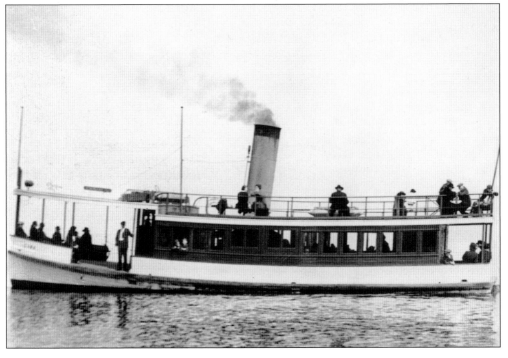

LAKE WASHINGTON FERRIES
SCHEDULE EFFECTIVE DECEMBER 11, 1930

Mercer Island Route		Seattle-Medina Route		Seattle-Kirkland Route	
Lv. Seattle Leschi Park	Lv. Roanoke	Lv. Seattle Leschi Park	Lv. Medina	Lv. Seattle Madison Park	Lv. Kirkland
* 6:25 A.M.	* 6:40 A.M.			* 6:15 A.M.	* 5:45 A.M.
* 6:55 A.M.	* 7:15 A.M.	* 5:40 A.M.	* 6:00 A.M.	7:15 A.M.	6:45 A.M.
* 7:30 A.M.	* 7:50 A.M.	6:30 A.M.	6:50 A.M.	8:30 A.M.	7:45 A.M.
8:05 A.M.	8:25 A.M.	* 7:05 A.M.	* 7:25 A.M.	9:45 A.M.	9:10 A.M.
9:00 A.M.	9:15 A.M.	7:40 A.M.	8:00 A.M.	10:55 A.M.	10:20 A.M.
10:50 A.M.	10:45 A.M.	8:20 A.M.	8:40 A.M.	12:00 Noon	11:30 A.M.
1:30 P.M.	1:45 P.M.	9:00 A.M.	9:15 A.M.	1:30 P.M.	1:00 P.M.
3:45 P.M.	4:00 P.M.	10:00 A.M.	10:15 A.M.	2:30 P.M.	2:00 P.M.
5:00 P.M.	5:15 P.M.	11:00 A.M.	11:15 A.M.	4:00 P.M.	3:00 P.M.
* 5:35 P.M.	* 5:50 P.M.	12:00 Noon	12:30 P.M.	5:15 P.M.	4:45 P.M.
6:10 P.M.	6:25 P.M.	1:00 P.M.	1:15 P.M.	6:05 P.M.	5:40 P.M.
6:45 P.M.	7:00 P.M.	2:00 P.M.	2:15 P.M.	7:00 P.M.	6:30 P.M.
8:30 P.M.	† 8:40 P.M.	3:00 P.M.	3:15 P.M.	8:00 P.M.	7:30 P.M.
10:40 P.M.	10:55 P.M.	4:00 P.M.	4:15 P.M.	9:00 P.M.	8:30 P.M.
12:00 P.M.	† 12:10 A.M.	5:00 P.M.	5:15 P.M.	10:30 P.M.	9:30 P.M.
		5:35 P.M.	5:50 P.M.	12:00 P.M.	11:30 P.M.
		* 6:10 P.M.	* 6:25 P.M.		
		6:45 P.M.	7:10 P.M.		
		7:30 P.M.	8:00 P.M.		
		8:30 P.M. (Via Roanoke)	9:00 P.M.		
		10:00 P.M.	10:20 P.M.		
		11:15 P.M.	11:35 P.M.		
		12:00 P.M. (Via Roanoke)	12:25 A.M.		

*Omitted on Sundays and Holidays.

† (Via Medina)

Automobile Rates

Light Car—2600 lbs. and under—
One Way..................................50c
Round Trip.............................75c
Heavy Car—Over 2600 lbs.—
One Way..................................60c
Round Trip.............................90c

Commutation Rates
Half of One-Way Fare
All Rates Include Driver

*Omitted Sundays and Holidays.

Saturdays Only
Overlake Golf Club Special Trip
Lv. Seattle 12:30 P.M.
Lv. Medina 12:45 P.M.

*Omitted Sundays and Holidays.

* Only 20 minutes crossing the lake to Kirkland.

J. L. ANDERSON, Operator
Leschi Park, Seattle
Phone EAst 5100

The Lake Washington ferry route shows that the cost of a single trip was 50¢ in 1930. On cold mornings, passengers found warmth around the boiler in the cabin. A flashlight was part of a commuter's life in order to make their way home through the dark forests after the *Dawn* dropped them off at their dock. (Courtesy Elizabeth Park Luis.)

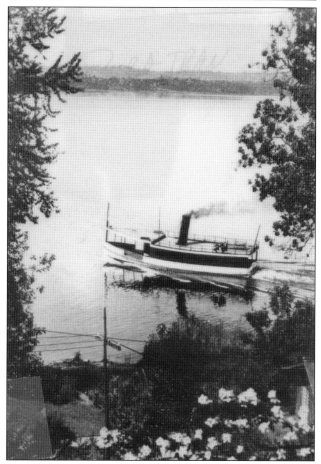

The steamer *Dawn* was built at Houghton in 1915 by Anderson Shipyard. Her first master was Capt. Harry J. Wilson. The blast of its whistle echoing along the shores was a pleasant and familiar sound to island residents who came to depend upon the little ship. Daily, it carried them to their work or school and home again at night. For the island dwellers, the *Dawn* was a part of their lives. (Courtesy the Museum of History and Industry.)

Captain Matson is shown seated in the front row, second from the right, in this photograph. Capt. Matson piloted the *Dawn*, and many island residents knew him well. In October 1938, the *Dawn* was taken off the run and replaced by the steamer *Mercer*. In 1945, the *Dawn* was sunk off the southern point of Mercer Island. (Courtesy the Museum of History and Industry.)

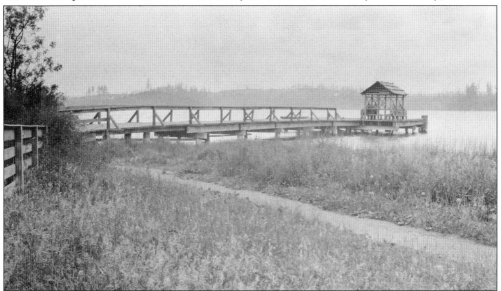

Boy's Parental School wharf is pictured here in 1912. According to the King County engineer's records of wharves and bridges, the wharf at the school was constructed with cedar piles by the county road supervisor in 1917. The Boys Parental School was a school for boys who came from broken homes or had alcoholic parents. Boys went a half-day to school and spent the rest of the day on the farm. (Courtesy King County Archives.).

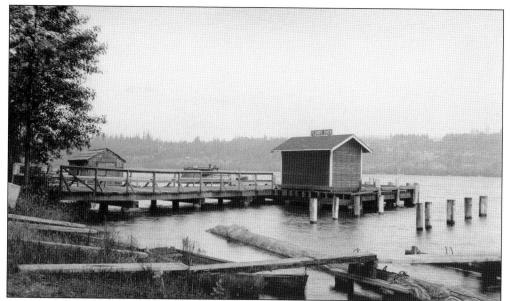

Flood's landing wharf is pictured about 1932. In 1946, the King County Engineer's records of wharves, bridges, flood's landing wharf was noted as being "a small boat landing in fair condition for recreational use." (Courtesy King County Archives.)

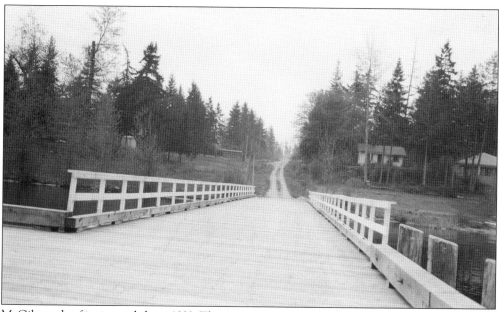

McGilvra wharf is pictured about 1932. The recommendations in the 1915 county engineer's report were to make repairs in the amount of $100, and if a waiting room was to be completed, to add five windows and a door, totaling another $25. As of October 1916, a new wharf was built, according to the county engineer's record of bridges and wharves. (Courtesy King County Archives.)

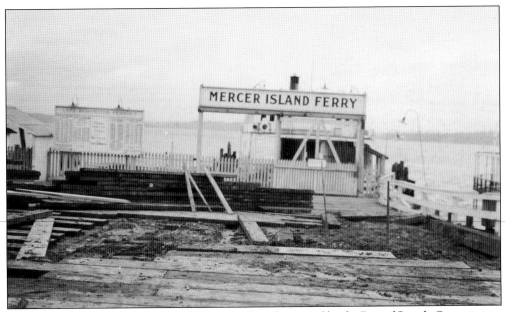

The Leschi ferry wharf, pictured in 1932, was built and operated by the Port of Seattle Commission. A number of ferries carried people, goods, and vehicles across Lake Washington before floating bridges were built. The ferry *Leschi* was launched here in December 1913. (Courtesy King County Archives.)

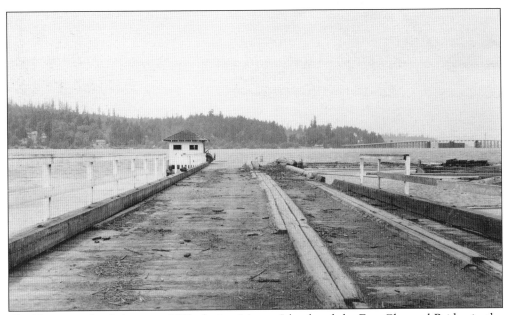

The Newport wharf, shown in 1932, depicts Mercer Island and the East Channel Bridge in the background. The Newport wharf served ferries on the east side of Lake Washington, such as the *Leschi* and the *Atlanta*. (Courtesy King County Archives.)

This bridge, known as Flood's Slide Bridge, was a quarter mile south of Flood's wharf on Mercer Island Boulevard. There was a very steep grade on the connecting road, which limited traffic to pedestrians or "light horse drawn vehicles," according to the 1925 King County engineer's office of records of bridges and wharves. (Courtesy King County Archives.)

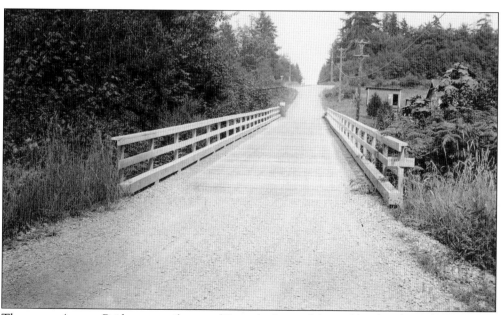

Thompson Avenue Bridge, one mile east of Roanoke Inn on Mercer Island, is shown here in 1932. By June 1946, all vestiges of the wharf were gone, according to the King County engineer's office of records of bridges and wharves. According to the King County engineer's notes, the wharf was "under the shore structure of the Lake Bridge" at that time. (Courtesy King County Archives.)

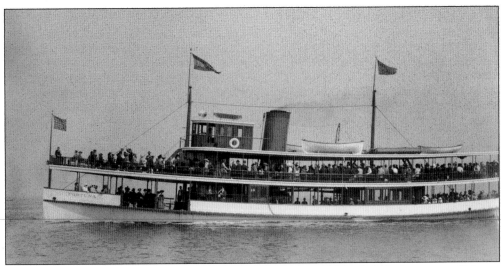

The *Fortuna* ferry offered excursions around the island in the 1920s and 1930s, stopping at Fortuna Park for picnics, dancing, games, swimming, and other fun activities. She was launched March 31, 1906, and was built a half-mile south of Leschi Park by the Anderson Shipbuilding Corporation. (Courtesy Puget Sound Maritime Historical Society.)

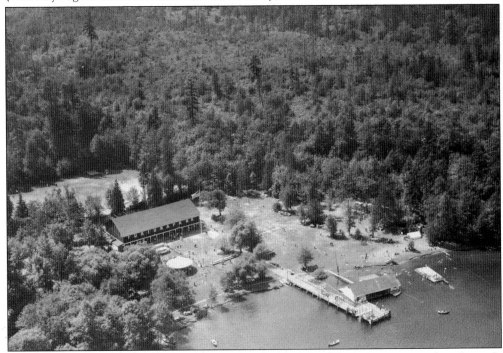

Fortuna Park was a popular destination of the *Fortuna* ferry. The park was created in the early 1900s by Capt. John Anderson, boat builder, ferry owner, and operator. He bought land, cleared it, and laid out playfields. He built a dock and a large, barnlike building for a dance hall with an excellent hardwood floor. The park was more often chartered by club groups from Seattle than it was used by the island's residents, except for the all-island bash. Steamers called at each dock to transport everyone to Fortuna Park for a great all-day family picnic. (Courtesy Museum of History and Industry.)

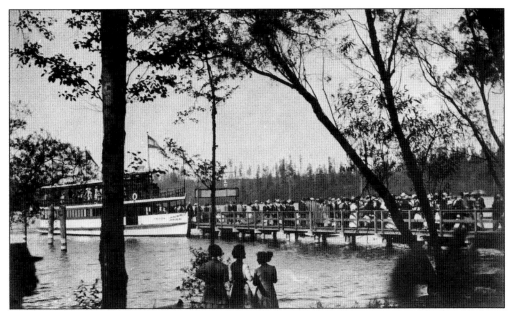

In 1909, the Anderson Steamboat Company built the *Triton* ferry at Houghton, Washington, for use on Lake Washington. The *Triton* left Leschi park 11 times daily for Medina, Bellevue, and "The Scenic Route," according to a 1911 advertisement from the Anderson Steamboat Company. (Courtesy the UW Library.)

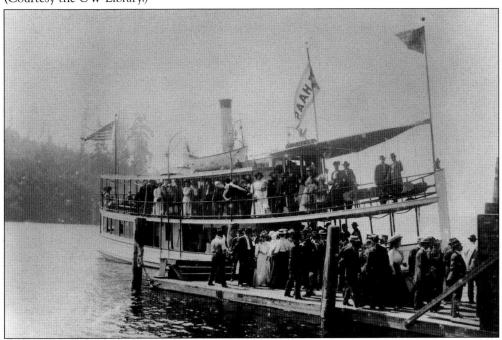

The *L.T. Haas* ferry, launched in 1902, was originally operated by Harry Cade and the Carlson brothers, who, doing business as the Interlaken Steamship Company, ran her on the Leschi Park–Meydenbauer Bay route. Later, Capt. John Anderson of Anderson Steamboat Company acquired the *L.T. Haas* when he merged the Interlaken Steamship Company with his own enterprise. The *L.T. Haas* was destroyed in 1909 by fire while on the lake. (Courtesy the UW Library.)

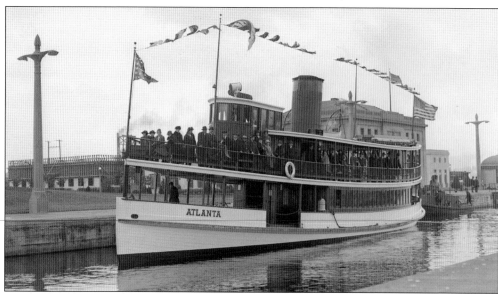

The *Atlanta* passenger ferry also stopped at Fortuna Park. The *Atlanta* was built at Houghton by the Anderson Shipbuilding Company in 1909. In 1923, the Anderson Shipbuilding Company was bought by Charles Burckardt. He renamed the site the Lake Washington Shipyard and used it as a freshwater tie up for his salmon fleet. During the 1920s, the yard made the transition from wooden boat making to steel shipbuilding. (Courtesy Puget Sound Maritime Historical Society.)

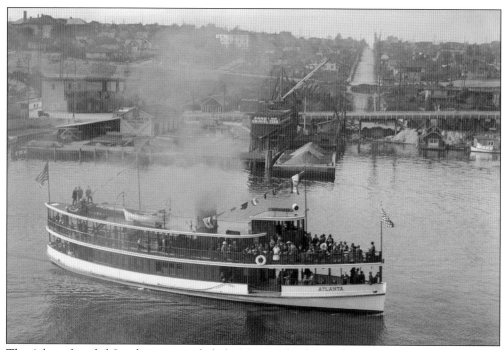

The *Atlanta* ferry left Leschi six times daily for Mercer Island. It took 20 minutes to get from Leschi to Bellevue, even less than that to get to Mercer Island, depending on the weather. In 1939, the *Mercer* and the *Leschi* carried 505,813 passengers. This gives an idea of the extent of passenger travel on the lake at that time. (Courtesy Puget Sound Maritime Historical Society.)

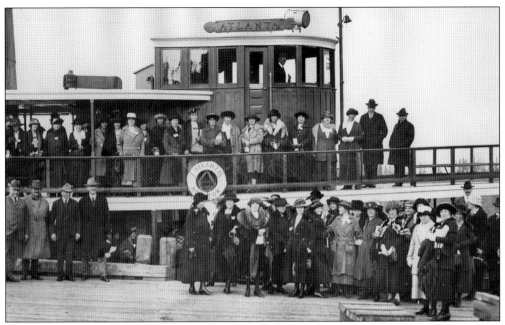

The *Atlanta* ferry is shown carrying the Seattle School Board for a visit to the Boys Parental School in 1919. At that time, the Boys Parental School was under the jurisdiction of the Seattle School District. In September 1954, the school board ordered the closure of the school because the acceptance of students from outside the district "imposes on Seattle taxpayers an unfair and inequitable expense." (Courtesy Seattle Public School Archives.)

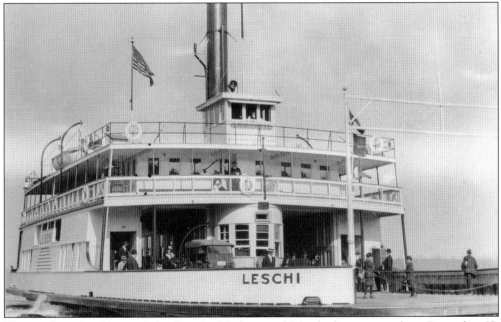

The car ferry *Leschi* served the Seattle, Medina, and Meydenbauer route from December 27, 1913, to August 31, 1950. The *Leschi* stopped calling regularly at Meydenbauer Bay in 1921 but continued on the Medina route. It was the first ferry in Washington designed for motor vehicles. (Courtesy Puget Sound Maritime Historical Society.)

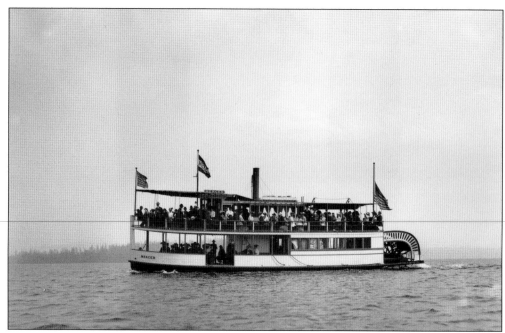

The *Mercer* car ferry, previously known as the *Vashon Island,* sailed on Lake Washington. She was built on the Duwamish River by McAteer Shipbuilding Company in 1916. The vessel was brought to Lake Washington in 1924, and the name was changed to the *Mercer.* She replaced the *Fortuna* in service to Mercer Island. (Courtesy Puget Sound Maritime Historical Society.)

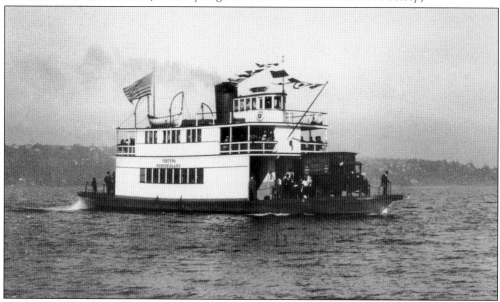

In 1919, the *Fortuna* was reconstructed as a car ferry at Captain Anderson's Shipyard at Houghton, Washington. She loaded cars at a single end, with a 15-car capacity. The procedure was to land bow first at Roanoke on Mercer Island, back out, and turn around to cross the lake to Leschi in Seattle, where again she turned and backed into the ferry slip in order that cars could drive off over her stern. This took great skill by her captain and engineer. (Courtesy Puget Sound Maritime Historical Society.)

Three

BRIDGES

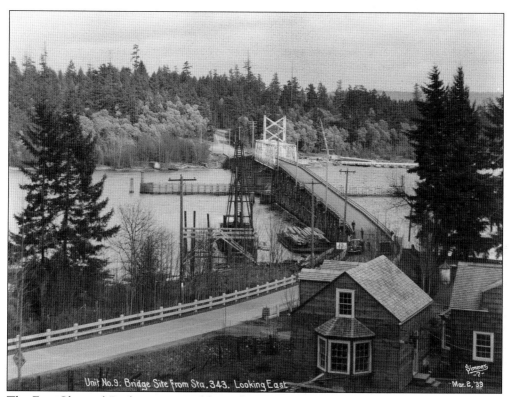

Unit No.9. Bridge Site from Sta. 343. Looking East. Mar. 2, '39

The East Channel Bridge is pictured here, facing east. Mercer Island's earliest connection to Lake Washington's east shore was this truss bridge, constructed in 1923 and replaced in 1940. The photograph looks east from Mercer Island across the channel at Enatai, Washington, with construction of the new bridge just getting started on the Mercer Island shore. (Courtesy Washington State Department of Transportation Library.)

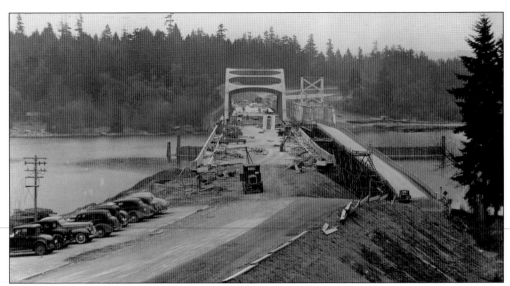

The East Channel Bridge officially opened on November 10, 1923, making way for development on Mercer Island. A concrete and steel span replaced the wood truss across the East Channel in 1940. This bridge was replaced in 1981 by a pair of structures with a total of eight lanes. (Courtesy the Washington State Department of Transportation Library.)

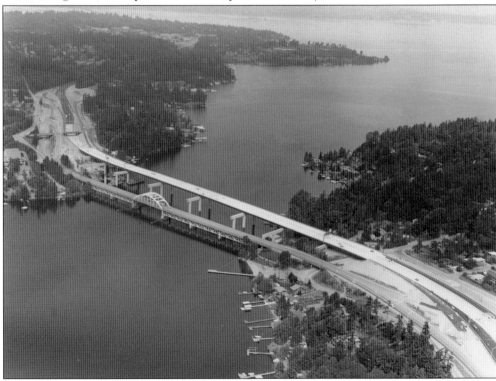

This aerial photograph shows the completed East Channel Bridge, with the old and new spans, in 1981. The bridge connects Enatai in Bellevue with Barnabie Point on northeast Mercer Island and allows easy automobile access to the island for the first time. (Courtesy the Washington State Department of Transportation Library.)

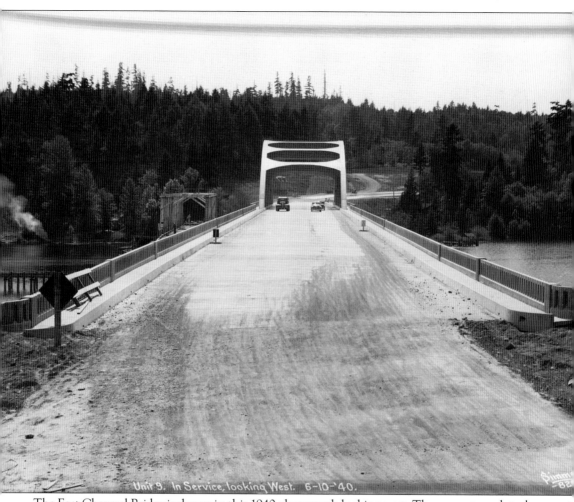

Unit 9. In Service, looking West. 6-10-'40.

The East Channel Bridge is shown in this 1940 photograph looking west. The concrete and steel span replaced the wood truss of 1923. Before the bridge, the only way to get to Mercer Island was by passenger boat. Soon after the end of World War I, developers realized that Mercer Island's potential was mostly untapped, owing to the lack of automobile access. The closest distance to the mainland was on the northeast section of the island, and plans were drawn up for a wooden bridge that would last 10 to 15 years. (Courtesy Washington State Department of Transportation.)

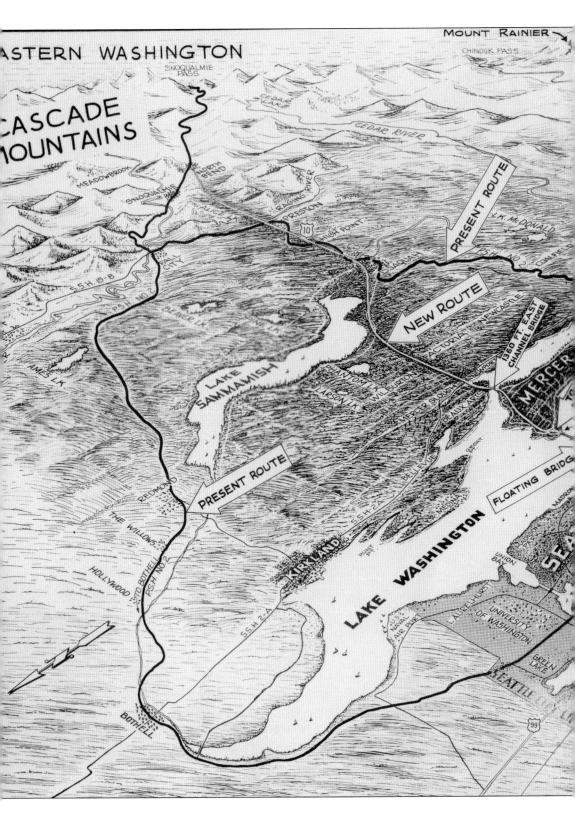

48

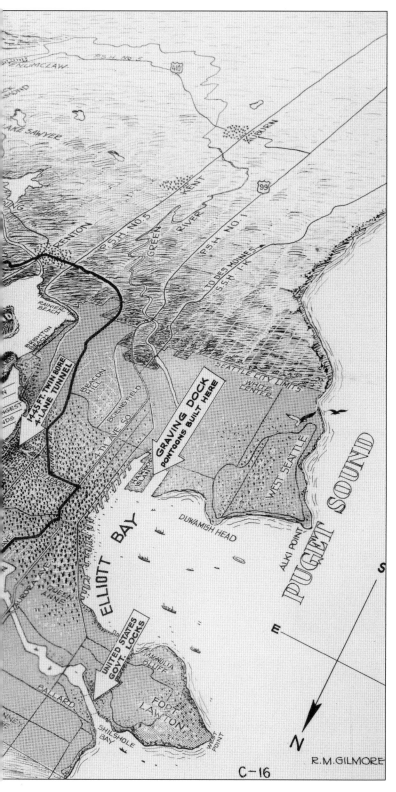

The map includes the following labels:

ENUMCLAW
410
LAKE SAWYER
KIRUN
99
KENT
RENTON
P.S.H. NO. 5
GREEN RIVER
P.S.H. NO. 1
TO DES MOINES
S.S.H. 1-K
RAINIER BEACH
RENTON BRIDGE
1445 FT. TWIN BORE 4-LANE TUNNEL
BEACON HILL
BOEING FIELD
14TH AVE SO.
GRAVING DOCK PONTOONS BUILT HERE
SEATTLE CITY LIMITS
WHITE CENTER
WEST SEATTLE
HARBOR ISLAND
ELLIOTT BAY
DUWAMISH HEAD
ALKI POINT
PUGET SOUND
UNITED STATES GOVT. LOCKS
MAGNOLIA BLUFF
FORT LAWTON
BALLARD
SHILSHOLE BAY
WEST POINT
S
E
N
R. M. GILMORE
C-16

This illustration shows the proposed route of the new bridge across Mercer Island to be completed in 1940. The bridge's selling point was clearly the shortening of the route from Seattle across the Cascade Mountains, but its real impact would be to open up Lake Washington's east side to booming development. To the west on Harbor Island are the graving docks where the floating pontoon sections would be built. (Courtesy the Washington State Department of Transportation Library.)

49

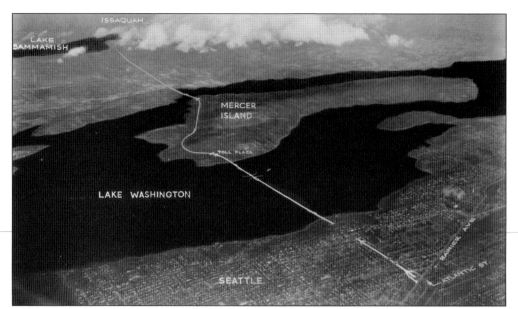

This is an aerial view of the proposed Lake Washington Bridge and the proposed new highway east from Seattle crossing Mercer Island. In 1937, Homer Hadley, who had been a designer in a Philadelphia shipyard, proposed to Lacey V. Murrow, then director of highways, that costs be studied for a reinforced concrete pontoon bridge crossing Lake Washington from the northern end of Mercer Island and piercing Mount Baker Ridge at its narrowest point. (Courtesy the Washington State Department of Transportation Library.)

Construction on the bridge began on January 1, 1939, and was completed 18 months later on June 30, 1940. This photograph looks east towards Mercer Island. It shows construction beginning on the tunnel and the pontoons being laid. It was the largest floating structure ever built at that time. It is actually a steel bridge encased in concrete. For every $1 worth of cement, $3 worth of steel was used in building pontoons. (Courtesy Museum of History and Industry.)

Looking east towards Mercer Island, this photograph shows the bridge taking form. It was the largest and longest bridge of its type at over 8,750 feet (over one mile) and was the first to be constructed of reinforced concrete. It contained 25 floating pontoon sections, each 350 feet long. Construction costs for the entire project totaled nearly $9 million. More than 3,000 workers were employed for 18 months, with 1,200 on the job site and the remainder behind the lines, getting out materials and supplies. During the entire construction period, not a single worker was killed. (Courtesy Museum of History and Industry.)

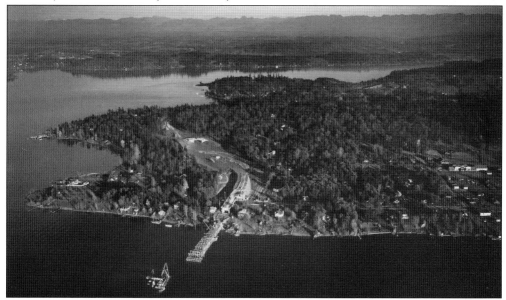

This 1940 aerial view shows the bridge under construction from the Mercer Island side of the lake. The relative economy of a pontoon bridge arose from the problems presented by the lake itself. The water is 150 feet to 180 feet deep, and the soft mud on the bottom extends down nearly an equal distance. It was estimated that the pontoon bridge would be one-fifth the price of a conventional bridge structure. (Courtesy Washington State Department of Transportation.)

Horace McCurdy was a shipbuilder, bridge builder, civic leader, native Washingtonian, and most enduringly, a supporter of maritime research and maritime collecting in the Pacific Northwest. The structures built by his firm, Puget Sound Bridge and Dredging, include the Lake Washington Floating Bridge (1940) and the Hood Canal Bridge (1961). McCurdy is pictured here in front of a model of his yacht *Blue Peter* in 1967. (Courtesy Museum of History and Industry.)

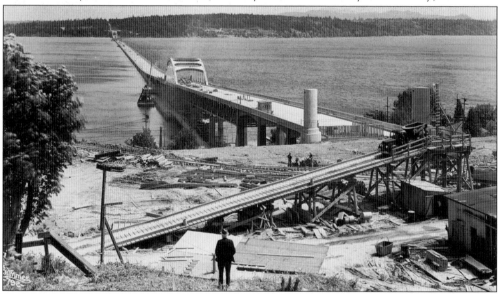

Looking east across Lake Washington, the bridge nears completion. The 25 pontoon sections were constructed in two graving docks on Harbor Island, then owned by the Puget Sound Bridge and Dredging Company, one of the four joint venture contractors. The docks were built side-by-side to enable them to be supplied from the same concrete batch plant. Outer forms were built inside the docks, steel reinforcing was placed in floors and walls, and then wooden form units were placed in the docks. Under this plan, the continuous pouring operation required less than two days. Walls were stripped in 24 hours, and the entire section was floated out five days later. Completed sections were towed across Elliott Bay, through the Ballard Locks, and into position on Lake Washington. (Courtesy Washington State Department of Transportation.)

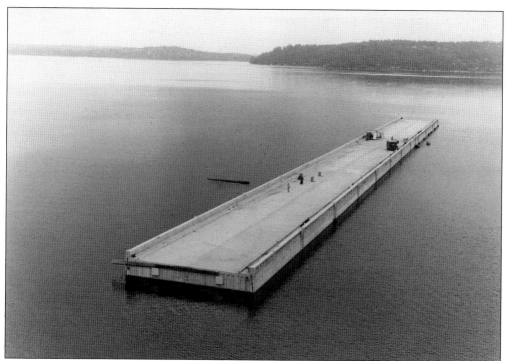

A pontoon section is seen being floated into position. The floating bridge, rather than a cantilever or suspension bridge, was selected because it is by far the most economical and because lake conditions were ideal for this type. (Courtesy Washington State Department of Transportation Library.)

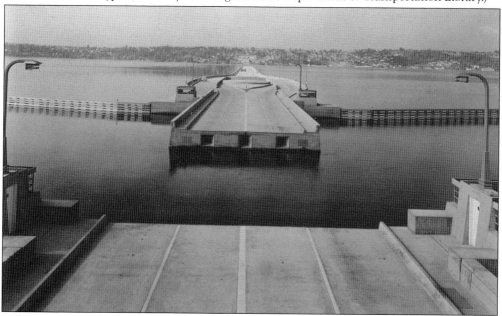

The floating sections of the bridge were rigidly connected end-to-end, forming a continuous box girder across the lake. Drawing up on the connecting bolts compressed a rubber gasket between the ends of the pontoons, forming a water seal. The one-inch space between pontoons was then pumped out and grouted. (Courtesy Washington State Department of Transportation Library.)

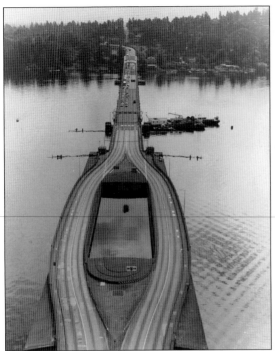

The bridge had a sliding draw part (a bulge) that required traffic to make a sharp turn at high speeds. Because of this bulge, the bridge became notorious for accidents, some of which were fatal. In 1981, the Washington State Department of Highways replaced the bulge with straight pontoons. In 1989, a parallel twin bridge, the Homer Hadley Bridge, was completed. (Courtesy Washington State Department of Transportation Library.)

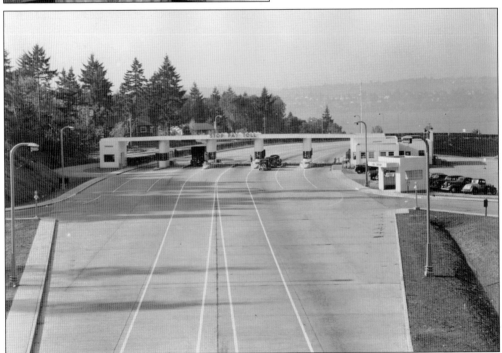

This photograph shows the approach to the toll station. Gov. Clarence D. Martin paid the first toll to cross the bridge. Toll charges mostly applied to automobiles but included 35¢ for wagons drawn by one or two horses and 50¢ for wagons drawn by three or more horses. The bridge saved up to an hour of commuting time to Seattle. (Courtesy Washington State Department of Transportation Library.)

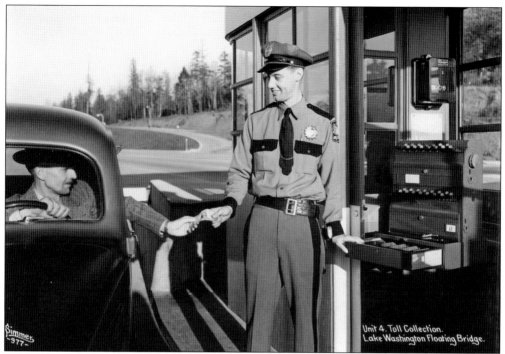

The floating bridge opened to traffic as a toll bridge July 2, 1940, between Seattle and Mercer Island, crossing Lake Washington. The tolls were removed in 1949, after generating $5.9 million in revenue. Revenue financing provided for the construction of toll bridges on public highways by the Washington Toll Bridge Authority. (Courtesy Washington State Department of Transportation Library.)

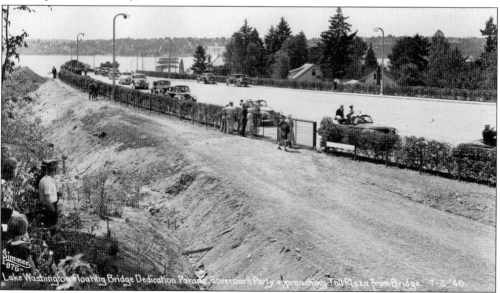

Governor Martin's party approaches the toll plaza from the bridge on the way to the dedication ceremonies on July 2, 1940. It was the first concrete pontoon floating toll bridge of its kind in the Pacific Northwest and the largest floating structure ever built. (Courtesy Washington State Department of Transportation.)

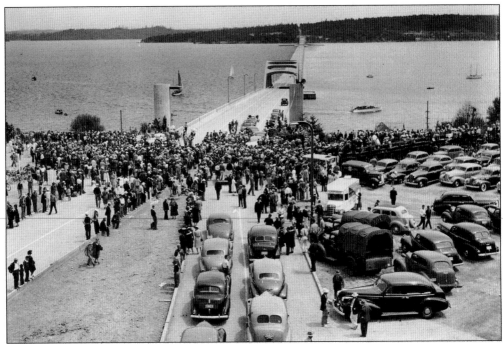

Beginning at 11:15 a.m. on July 2, 1940, dedication ceremonies were held for the Lake Washington Floating Bridge (also called Mercer Island Bridge). The bridge carried US 10 (later decommissioned and renamed Interstate 90) across from the Mount Baker neighborhood of Seattle over Mercer Island to a point south of Bellevue. (Courtesy Washington State Department of Transportation.)

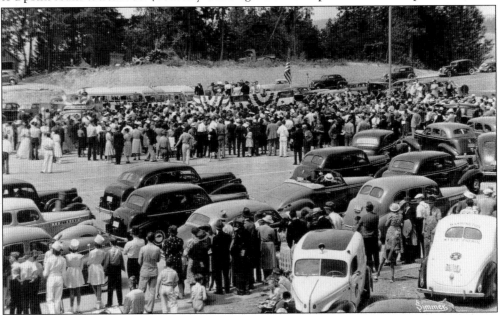

The dedication went off with great fanfare. Two thousand people attended on the east side of the bridge. A ribbon was cut, and an urn containing water from 58 Washington streams and lakes was smashed against the side of the bridge. Later, there were swimming races, fancy diving, surfboarding, and waterskiing exhibitions. (Courtesy Washington State Department of Transportation.)

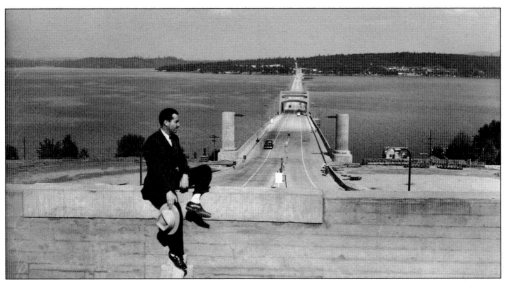

Lacey V. Murrow is sitting on the bridge in 1940. Murrow was the Washington State Highway director and brother of famed newsman Edward R. Murrow. Lacey Murrow was appointed highways director by Gov. Clarence D. Martin in 1933. He resigned in 1940 to go on active duty with the Army. He served as a pilot in Europe, the Mediterranean, the South Pacific, and the China-Burma-India Theater, logging more than 4,000 hours of flying, mostly in B17 and B24 bombers. (Courtesy Museum of History and Industry.)

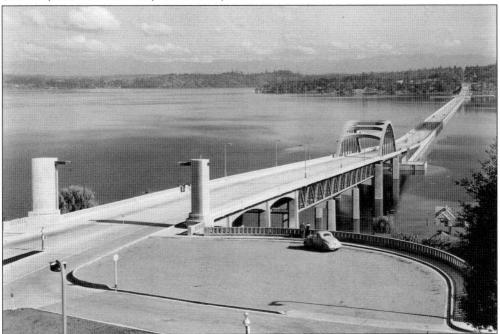

This view of the bridge looks west towards Seattle from Mercer Island. In 1967, the Lake Washington Floating Bridge was renamed the Lacey V. Murrow Memorial Bridge. In 1994, the bridge was named by the National Society of Professional Engineers (NSPE) as one of the top 10 engineering achievements of 1993 in the NSPE 28th annual Outstanding Engineering Achievement Awards Competition. (Courtesy Washington State Department of Transportation.)

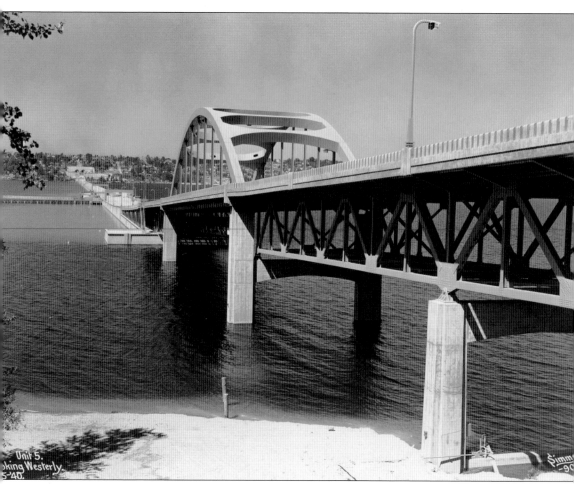

The completed bridge is shown here looking west. On November 25, 1990, during a storm, the bridge sank. It had been under repair, and bridge workers had left open the hatchways to the hollow pontoons, which filled with water during the storm. Nine of the 25 pontoons sank. The bridge was later rebuilt. The lake bottom consists of 200 feet of very soft clay, silt, and organic material. To build a typical bridge, a foundation would have to consist of caissons nearly 400 feet long. A floating bridge eliminates the need for conventional piers and foundations, as it takes advantage of buoyancy to support dead and live weight. It uses concrete pontoons anchored to the lake bottom by a minimum of two steel anchor cables per pontoon. (Courtesy Washington State Department of Transportation.)

Four

BUSINESSES AND INSTITUTIONS

George McGuire built the Roanoke Inn in 1914, and it is the oldest and longest running business on Mercer Island. It served as a chicken dinner spot for curious motorists who took the ferry over from Seattle in order to explore the island. After prohibition, when it was a tavern, groceries, ice cream, and pop were sold there. (Courtesy Dorothy Reeck.)

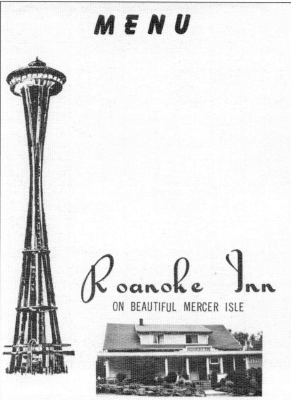

MENU

Roanoke Inn
ON BEAUTIFUL MERCER ISLE

At first, business was not great, and McGuire lost the inn because of debts. A Mr. Green took over and operated it as a hotel. The inn was then sold many times, sometimes falling under ill repute. It was rumored to be a brothel and sold liquor in coffee mugs during prohibition. (Courtesy Dorothy Reeck.)

In 1943, Edwin and Laura Reeck purchased the inn. They made it a proper inn, with meal service as well as beer and wine. Their son, Hal Reeck, married Dorothy, and after his death, she has continued to run the establishment. It is still a friendly gathering place for islanders and off-islanders that appreciate the working fireplace and cozy atmosphere. (Courtesy Dorothy Reeck.)

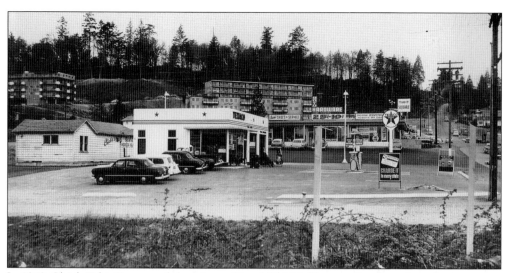

In 1949, Chick Tabit Sr. opened the Mercer Island Chick's Shoes on land purchased as a summer home. This photograph shows the little house on the far left and Tabit Square as it was from 1960 until its current configuration around 1983. Several generations of Tabits have worked in the store. (Courtesy Tabit family.)

Joe Tabit, Chick Tabit Jr., and Chick Tabit Sr. are pictured here from left to right. The younger Tabit appears to be learning the trade while his elders look on. At least one Tabit from each generation has become a cobbler, each adding a new dimension to the business. (Courtesy Tabit family.)

Chick Sr. was a welterweight boxer while he had his own shoe repair at the foot of Queen Anne Hill in Seattle. His father before him, "Papa Joe," had also been a cobbler in the "old country" (Lebanon), when the trade was considered an art form. This patriarch began American cobbling with a shop in Belltown in 1910. (Courtesy Tabit family.)

"C.J." Tabit is the fifth-generation Tabit to become a cobbler. He is the resident pedorthist, casting and shaping custom orthotics into shoes for people with troublesome feet. Sometimes people with bad backs or knees learn that with proper shoes, their issues lessen, according to C.J.'s father, Chris Tabit. (Courtesy Tabit family.)

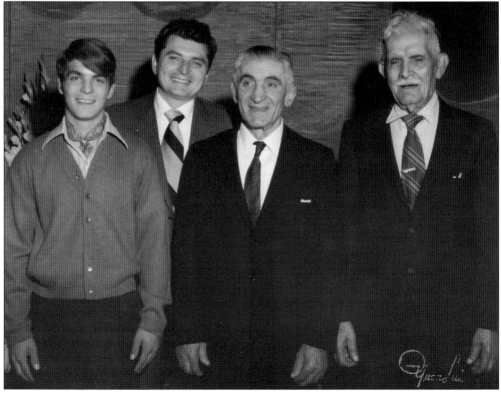

Chick Tabit Jr. and his wife, Julie Tabit, are shown with their dog "Spotty" in the early 1950s. They lived in the little house and ran the shoe repair out from the store in front of the house. The store is part of Tabit Village Square today, home to several businesses, including Starbucks, UPS, and Subway. (Courtesy Tabit family.)

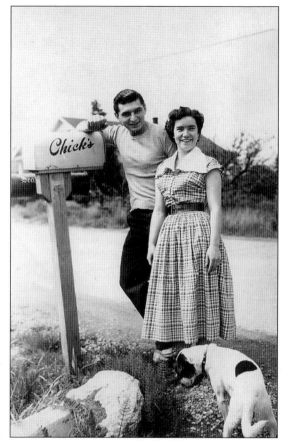

Chick Tabit Sr.'s wife, Mary, purchased two acres on Mercer Island in the 1940s. The front acre is where the shopping center is now located. The second acre is where a Key Bank is situated, to the south of Tabit Village Square shopping center. The second acre was sold in 1976. (Courtesy Tabit family.)

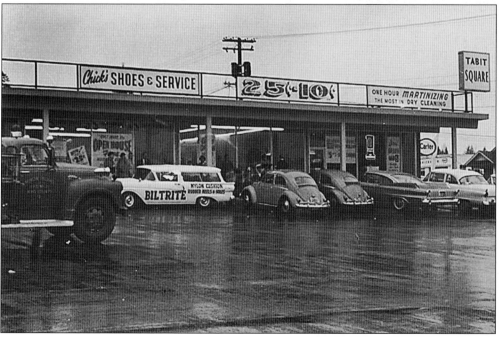

The Floating Bridge Inn opened in 1954 as a coffee shop in the quarters formerly operated as Hesse's Restaurant. It was owned by George Clarke, with Lou and Carl Lovsted as managers. The Floating Bridge Inn was one of the most successful restaurants on Mercer Island when the owners decided to close in 1967. (Courtesy Carl Lovsted.)

FLOATING BRIDGE INN RESTAURANT

The 1962 World's Fair in Seattle was one of the most profitable times for the Floating Bridge Inn, which benefitted from a lot of the spillover business from the fair. The rear banquet room, known as the "Bridge Room," could accommodate 90 people and included a cocktail lounge. (Courtesy Carl Lovsted.)

FLOATING BRIDGE INN
TUESDAY, MARCH 8, 1966

BANQUET FACILITIES AVAILABLE

Chef's Special Luncheon
Cup of Soup - Salad - Tomato Juice

#1	TURKEY A LA KING ON TOAST POINTS	1.15
#2	LITTLE PIG SAUSAGES, ESCALLOPED POTATOES	1.35
#3	BABY BEEF LIVER AND ONIONS	1.45

Roll and Butter - Beverage

GRILLED HAM AND SWISS CHEESE SANDWICH
Potato Salad
$1.10

BUDGET LUNCH - 96¢
FISH AND CHIPS
Tossed Salad - Beverage

LOW CALORIE SPECIAL
EIGHT OUNCE GROUND BEEF STEAK
SALAD OF THE DAY - TOAST - $1.20

8 OUNCE NEW YORK CLUB STEAK - $1.45
Tossed Salad - Egg Bread Toast

Snack Cup of Soup
GRILLED SWISS CHEESE SANDWICH ON RYE 75¢
Potato Chips and Pickle

64

"The Floating Bridge Inn was also called the FBI until the real FBI came and suggested we not call it that anymore," recalled George Clarke. Twenty-two businesses have resided at the city block of Mercer Island's business district, located on 7700 SE Twenty-seventh Street. (Courtesy Carl Lovsted.)

Constructed in 1922 by local craftsmen and volunteers, the Keewaydin Clubhouse was used by early residents to gather socially and discuss community issues; it has since been used privately and by both local government and civic organizations. It was purchased in 1966 by members of the Veterans of Foreign Wars (VFW) Post 5760 and remains a central gathering place for community members. (Courtesy VFW Post 5760.)

FLOATING BRIDGE INN RESTAURANT

Fruits and Juices

Pure Florida Orange Juice	.20-.30
Tomato Juice	.20-.30
Fresh Fruit (in season)	.35

Breakfast Specials

1. Ham, Bacon or Sausage, Two Eggs, Potatoes and Toast 1.35
2. Club Steak with Hash Browned Potatoes and Toast 1.60
3. Two Hot Cakes, Choice of Bacon, Ham or Sausage and one Egg . 1.10
4. Two Eggs, Potatoes and Toast75
5. French Toast with Maple Syrup75
6. Ham, Bacon or Sausage, Two Eggs and Toast 1.20
7. Fresh, Crisp Cereal, Country Fresh Egg,
 2 Strips of Bacon, Buttered Toast85

Hot Cakes

Buttermilk Pancakes (3)	.55
Short Stack (2)	.40
Blueberry Pancakes (3)	.75
Short Stack (2)	.55
Children's Dollar Size Pancakes	.35

Omelettes

Plain Omelette (3 eggs) with Toast	.90
Ham or Cheese Omelette (3 eggs) with Toast	1.20

Side Orders

Two Fresh Eggs	.50
Hot Butterhorn	.30
Donut	.15
Bacon, Ham or Sausage	.60
Toast with Jam	.25
Hash Browned Potatoes	.30
English Muffin	.25
Cereals with Cream	.35

Banquet Facilities... Dining Room... Cocktails from the Bridge Room

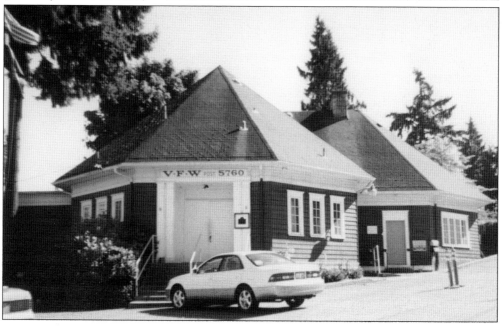

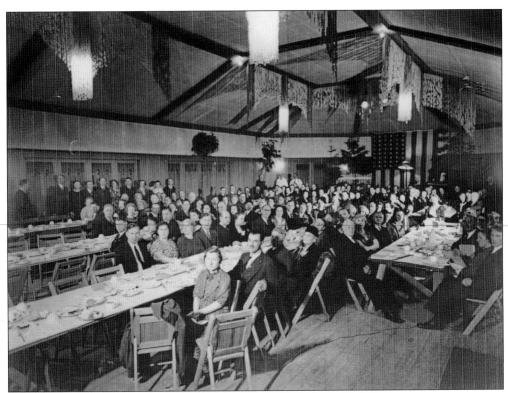

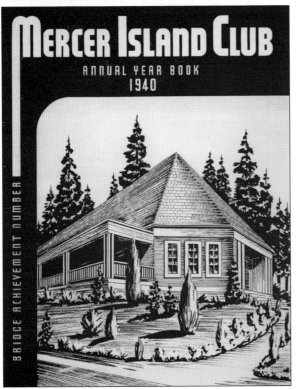

The clubhouse has served as a social center for the growing community of Mercer Island for over 50 years. During the 1930s and 1940s, the organization shifted focus from exclusively social to community issues, such as fire protection, water rights, and transportation. (Courtesy VFW Post 5760.)

The Keewaydin Club (an Indian name meaning "Of the Northwest Wind") was organized on November 29, 1921, by members of the Mercer Island Community Club. The club incorporated all of the island's improvement clubs within the north end and was promoted as being formed "for social purposes exclusively." (Courtesy VFW Post 5760.)

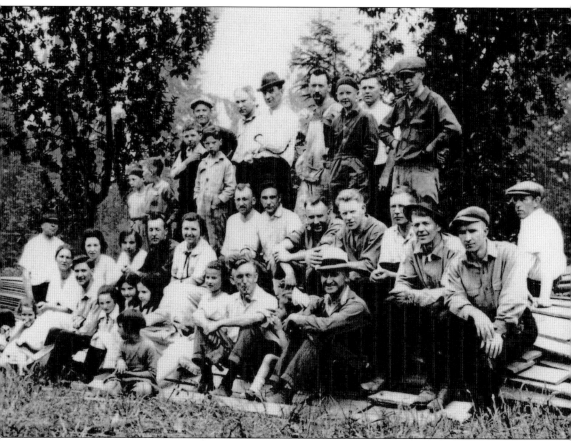

W.S. Foster and H.C. Raymer were elected to serve one-year terms as the club president and vice president, respectively. Under their leadership, a lot was purchased and cleared the following year. On a single day, July 1, 1922, approximately 60,000 feet of lumber and 58,000 shingles were hauled up the steep slope from the barge that had brought the cargo from Seattle. (Courtesy VFW Post 5760.)

On November 1, 1973, Island Books, Etc. was opened by Lola and Phil Deane. It was Lola's idea to have a bookstore on the island, and her husband built the bookshelves. He was a popular Island pediatrician, and the store still uses an old exam table of his for wrapping gifts. Roger Page came in 1983 as a Christmas/holiday wrapper, stayed, and later bought the store from Marge Wilkens, Elinor McDonald, and Fam Bayless in 1991. From left to right are (standing) Lola Deane, Craig Portmann, Ralph Portmann, and Doug Deane; (seated, left) Sally Kennedy and Andrea Lorey; (seated, right) Phyllis Thona and Stacie Portmann. (Courtesy Roger Page.)

The Wizard of Oz, a mid-1980s production, was a featured show at Youth Theatre Northwest, a popular theater on Mercer Island. Since 1984, Youth Theatre Northwest has been one of the region's premier youth arts organizations, providing a wide range of dynamic programming for thousands of children and families. (Courtesy Youth Theatre Northwest.)

Each year, Youth Theatre Northwest (YTN) presents 13 professional productions, offers year-round classes, and provides outreach programs for diverse communities throughout the region. For many children, their programs are an introduction to the performing arts and the magic of live theatre. YTN helps young people find their inner light of self-confidence, sensitivity, creativity, and leadership. (Courtesy Youth Theatre Northwest.)

This photograph shows the cast
from the mid-1980s production of
Alice in Wonder. Youth Theatre
Northwest is committed to the
intellectual, artistic, and personal
development of children through
education, performance, and
live productions. (Courtesy
Youth Theatre Northwest.)

For many children, "Youth Theatre
Northwest is their favorite place,"
says Manny Cawaling, current
executive director of the theater.
"After home and school, YTN
is the children's "third place."
"We offer a nurturing and safe
environment where kids can
learn and grow, succeed and
challenge themselves, develop
healthy relationships and
shine," Cawaling says. (Courtesy
Youth Theatre Northwest.)

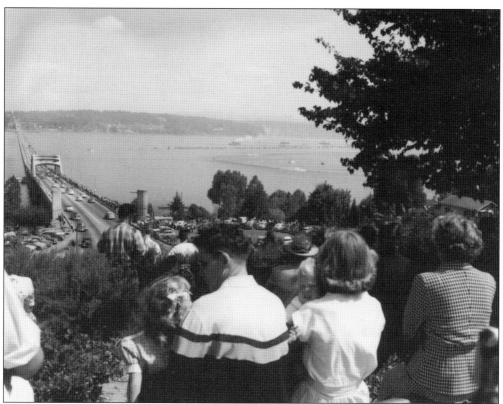

A crowd watches hydroplane races on the Lake Washington. Note the wakes left by the water planes. Seafair is an annual fair in Seattle, usually the first weekend of August, which celebrates the nautical with a parade, pirates, hydroplane races, boat building competitions, and more. (Courtesy Museum of History and Industry.)

Seafair began in 1952 as a plan to celebrate Seattle's centennial (1951–1952). The festival was designed to attract tourists and stress marine events in keeping with Seattle's boast as "the floating capital of the world." Hydroplane races are pictured in 1957. (Courtesy Roy Ellingsen.)

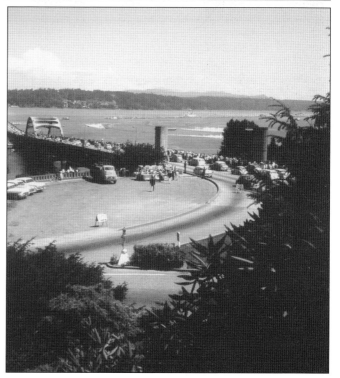

A blimp can be seen in this 1955 photograph by Erling Ellingsen. The first Seafair featured parades, boat races on Green Lake, amateur athletic events, royalty, community festivals like West Seattle Hi-Yu Days, Rainier District Pow Wow, Wallingford Pirate Days, the University District Kid's Parade, and the Ballard Festival, and were highlighted by the nightly Aqua Follies performances. Seafair was deemed a success, and the festival would grow the next summer with the addition of the unlimited hydroplane races on Lake Washington. (Courtesy Roy Ellingsen.)

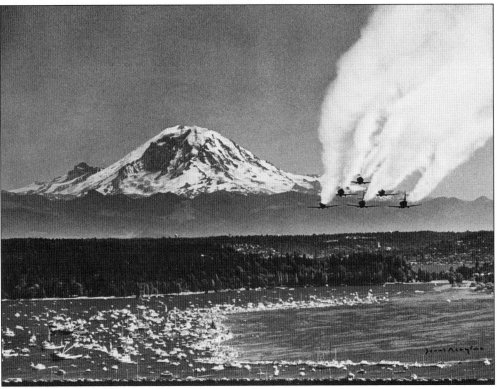

Mount Rainier can be seen to the southeast in this breathtaking photograph of the highlight of Seafair Festival in August 1978. Traffic on the floating bridges is cleared during the annual performance by the Blue Angels. In 2012, Seafair drew hundreds of thousands of spectators who luxuriated in the typically clear weather, showing off Lake Washington at its best. (Photograph by Joseph Scaylea, courtesy Museum of History and Industry.)

Five

CHURCHES

The island's first church was built in 1914, a goal that was realized by Rev. Thomas A. Hilton, a rector of St. Clement's Church in Seattle, and the small group of congregants of the Emmanuel Episcopal Church. The group first met in the home of the Warks family in East Seattle, then in the little white schoolhouse. The church soon became a meeting space, not only for church functions, but also community activities. (Courtesy Puget Sound Branch King County Archives.)

A large Sunday school group at Emmanuel Episcopal Church is pictured in the 1920s. For many of Mercer Island's early residents, spiritual and moral life, and much of their social life as well, centered on Emmanuel Episcopal Church, a small yet very influential institution. On a lot donated by Alex and Olga Meerscheidt at what is now West Mercer Way and SE Twenty-seventh Street, island resident and builder Charles Meyer constructed a small, rustic church of number-one clear timber for $1,760. The pews and alter, built by Lytel Millworks, cost an additional $80. (Courtesy Emmanuel Episcopal Church.)

David Wolf teaches Sunday school in this scene from the 1920s. By 1921, the activities of the church were numerous, and it became obvious that more space was needed for the church's functions, as well as for community activities. A new goal was set for the construction of the Guild Hall. Again, funds were raised, and bit-by-bit, labor was donated, and the Guild Hall was finally built west of the church, almost adjacent to the East Seattle School. (Courtesy Emmanuel Episcopal Church.)

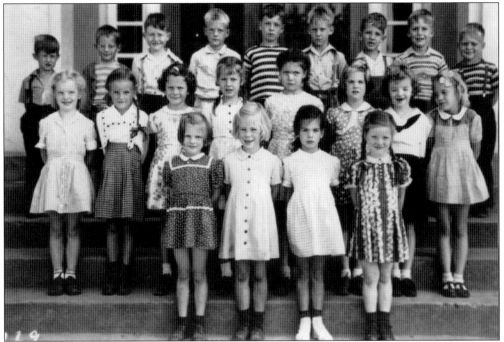

A group of Sunday school kids lined up outside the Guild Hall in the 1930s. The building was, for many years, the center of the island's activities; it housed Emmanuel's Sunday school, choir practices, Women's Auxiliary functions, the Mercer Island Library, Girl Scouts, Boy Scouts, and Camp Fire Girls. When play equipment and a fence were added in 1933, the Mercer Island Co-op Preschool was held there for nearly 20 years. (Courtesy Emmanuel Episcopal Church.)

A teen youth group meets in the Guild Hall in the 1940s. After completion of the Lake Washington Floating Bridge in 1940, the island's population grew and so did Emmanuel's. A minister who could serve the church full time and live on the island was needed, but housing was in short supply, and a vicarage was hard to find. In 1951, the stone "castle" originally built for Mr. and Mrs. D.B. McMahon across West Mercer Way from the Guild Hall was purchased. The home was sold by the church in 1957. (Courtesy Emmanuel Episcopal Church.)

Fred Kepler was the first vicar of the church, which was still a mission of the Diocese of Olympia, Washington. The leaders of Emmanuel decided to seek parish status, but one of the requirements for such status was the ownership of three acres of land, not available at the East Seattle location. An important decision was made, the church and Guild Hall were sold to the school district for $16,800, and a new site was purchased. (Courtesy Emmanuel Episcopal Church.)

Father Bigliardi (right) and his associate rector, Rev. Herbert McMurty, are shown in this photograph. Father Bigliardi was the vicar from July 1955 to January 1974 and was much loved by the community for his years of service. (Courtesy Emmanuel Episcopal Church.)

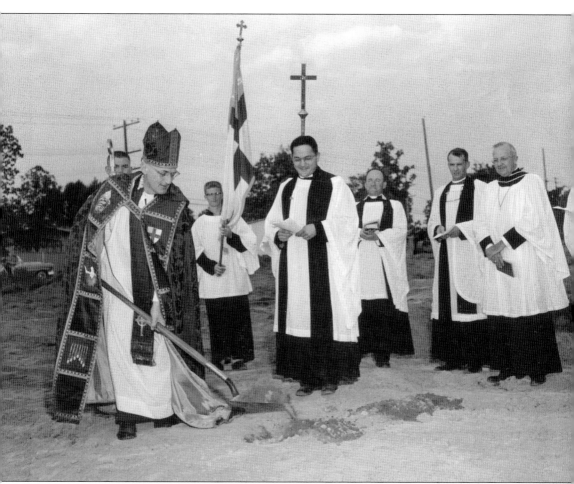

Five acres at SE Forty-sixth and Eighty-sixth Streets, part of the original Schmid homestead, were purchased for $25,000 in 1956. Until the new church was ready, the school district leased their old property back to Emmanuel for $1 a month for three years. In July 1955, Rev. Matthew Paul Bigliardi arrived, and on May 18, 1958, they broke ground on the new site. Here, Father Bigliardi stands beside Bishop Stephen Bayne as he shovels dirt on the new site. At the beginning of 1961, the church served briefly as city hall for the newly incorporated City of Mercer Island. Later that year, the offices were moved to Shorewood Apartments, and afterward, the church was burnt as a practice for volunteer firefighters. (Courtesy Emmanuel Episcopal Church.)

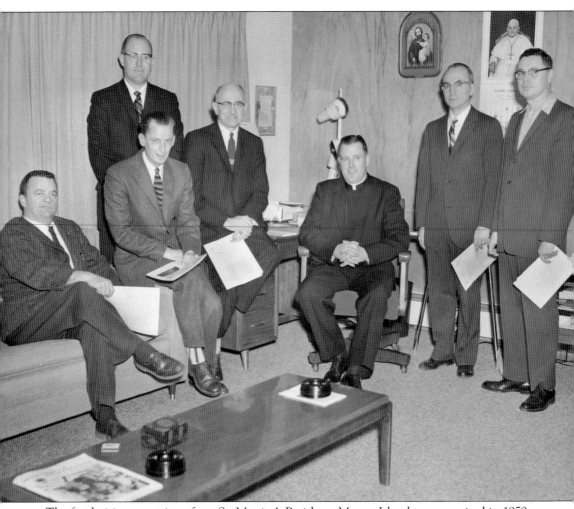

The fundraising committee from St. Monica's Parish on Mercer Island was organized in 1959 to finance construction of the first units of a parish plant. Father Walsh pointed out that the new parish had been established by the Most Reverend Archbishop to meet the needs of a growing Catholic population on Mercer Island. First units of the building program would include a temporary church, parish school, and convent. Serving Mercer Island from as far back as 1935, masses had been offered in various buildings around the island. From the Boys Parental School to the East Seattle School gymnasium, Catholics were given the opportunity to worship. With the new construction, parishioners were now able to enjoy worshiping in their own building. Members of the committee are, from left to right, John Donahue, Robert Allison, Henry Duex, Milton Link, Father Walsh, Dr. Donald Soltero, and James A. Walsh. (Courtesy St. Monica's.)

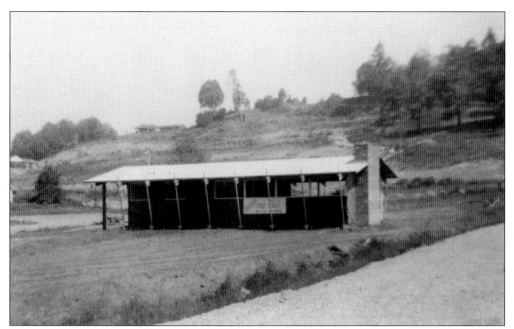

Mercer Island Covenant Church began as a Christian Sunday school for adults and children in May 1949 after a small group of interested people met, feeling God leading them in this direction. This group soon grew and began meeting in the Mercer Island Community Club, now the VFW Hall on North Mercer Way. (Courtesy Mercer Island Covenant Church.)

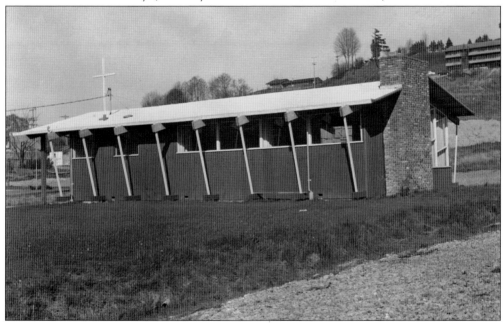

Formerly organized as the Mercer Island Community Church in 1951, the congregation became affiliated with the Evangelical Covenant Church of America, known then as the Mission Covenant Church. A lot where the Mercer Island Post Office is now located was purchased in 1954 for $4,500. The Fireside Chapel was built at the post office site. Two years later, the lot was valued at $12,400. (Courtesy Mercer Island Covenant Church.)

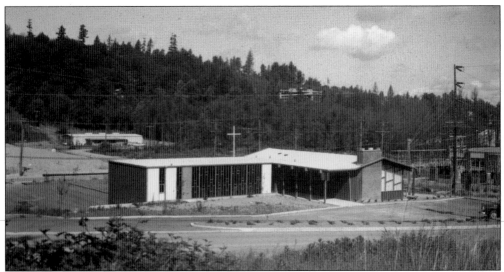

The present post office property was sold in the spring of 1959, and the congregation purchased the property across the street and moved the Fireside Chapel to the new location. A sanctuary, lower level, and a pastor's office were added. With a need for more classroom and office space, the congregation purchased the original building of the Herzl-Ner Tamid Synagogue on East Mercer Way in 1971. The building was moved to the property, and a new sanctuary was also added. (Courtesy Mercer Island Covenant Church.)

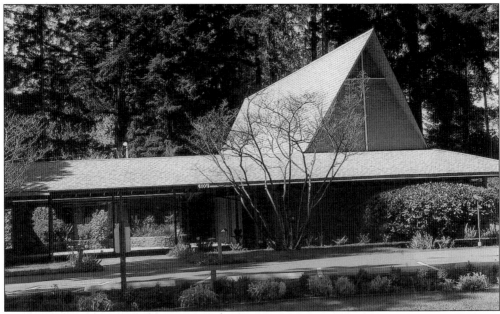

The history of Redeemer Lutheran Church began with a worship service on October 15, 1961, at the South Mercer Island Club, at Eighty-eighth (Island Crest Way) and SE Sixty-eighth Avenues, conducted by Rev. Bernhard Filbert. Ten days later, an organizational meeting was attended by Kenneth Baker, Maynard Hanson, Eugene Meixner, Walter Otto, Ernest Smith, and Pastor Filbert. Plans proceeded for building church facilities at a five-acre site between Sixtieth and Sixty-first Avenues SE and Island Crest Way, where the current church sits today. (Courtesy Redeemer Lutheran Church.)

Redeemer Lutheran Church is known for its annual live Nativity scenes, which are put on display during the holiday season. In this photograph, a young parishioner poses with a llama on a break between performances. (Courtesy Redeemer Lutheran Church.)

This is another scene from the live Nativity, this time with a cutout camel. A young person stands behind the cutout so he appears to be riding it. A verse is inscribed on the side of the camel. (Courtesy Redeemer Lutheran Church.)

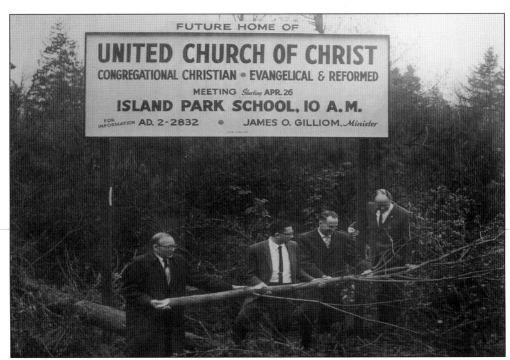

In 1963, the Washington North Idaho Conference, United Church of Christ, took steps toward a new church on Mercer Island by allocating funds and seeking out a sponsoring committee of 15 Mercer Island residents. They purchased a parcel of land on Island Crest Way for the future church. Here, church members break ground on the new church site. (Courtesy Congregational Church of Mercer Island.)

On September 16, 1906, Herzl Congregation was founded by a group of Orthodox Sephardic Jews. Just two years after his death, the synagogue was named for Theodore Herzl, credited for the Zionist movement that urged Jews to establish their own homeland in Israel. In 1966, Congregation Ner Tamid purchases a building at 15655 Lake Hills Boulevard in Bellevue. In the late 1960s, the decision was made for the Herzl Congregation to be merged with Ner Tamid. The merge officially happened in 1970. (Courtesy Museum of History and Industry.)

Rabbi Maurice Pomerantz was the rabbi at Herzl–Ner Tamid from the mid-1970s through the 1980s. (Courtesy Museum of History and Industry.)

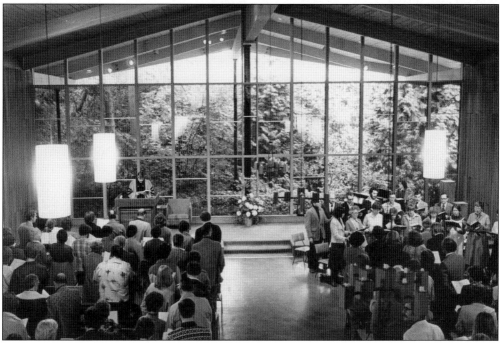

In 1948, Unitarian Sunday School on Mercer Island began holding classes in the rooms at Lakeview School. The next year, in 1949, the Mercer Island Fellowship was founded and moved to the Chapel of the Flowers in Bellevue, Washington. By 1955, East Shore Unitarian Church was formally organized. The parents of Stanely Ann Dunham (Pres. Barack Obama's mother) sent her to Sunday school at this church after they moved to the island in 1956. (Courtesy Eastshore Unitarian Church.)

In 1952, Eastshore Unitarian Church acquired the Henderson property, pictured here, in the Factoria area of Bellevue, Washington, where their new church was to be built. The sanctuary was dedicated in 1955, and the first wing of the church school was built in 1960. An addition of two wings to the church school occurred in 1963 to accommodate the over 300 children now attending Sunday school. By 1966, the sanctuary building was ready for expansion to increase the office, storage, and bookshop areas, and in 1990, the new administration building and religious education buildings were completed. In 2002, renovations to the education building and sanctuary and construction of a new multipurpose building were completed. (Courtesy Eastshore Unitarian Church.)

Mercer Island Presbyterian Church (MIPC) has witnessed a transition from a small pastoral church to a multi-ministry congregation with over 1,000 members. The MIPC began in 1951, however it was not until 1952 that a few people started meeting, first at the home of Daniel Prosser, then later at the Emmanuel Episcopal Chapel, then located near the East Seattle School on West Mercer Way. The fledgling congregation was formally organized as a Presbyterian Church on May 24, 1953. (Courtesy Priscilla L. Padgett.)

Six

PARKS

Luther Burbank Park, shown here much as it was in the early years of the 20th century, was an idyllic park setting. The park totals 77 acres, with a mile of Lake Washington shoreline, two distinct marshes, several large meadows, a beautiful swimming beach, a picnic area, and an urban core, which includes boat docks, plazas, tennis courts, an amphitheater, and a unique children's play area. (Courtesy Seattle Public School Archives.)

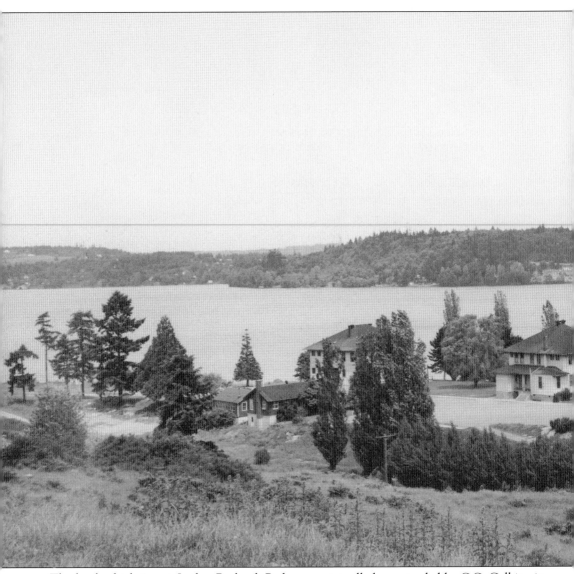

The land, which is now Luther Burbank Park, was originally homesteaded by C.C. Calkins in 1887. In 1903, the land was purchased by the Seattle School District and a school for delinquent and abandoned children was established under Cicero Newell. The school was named the Boys Industrial School. After a year under superintendent William Baker, Willis Rand, who had been

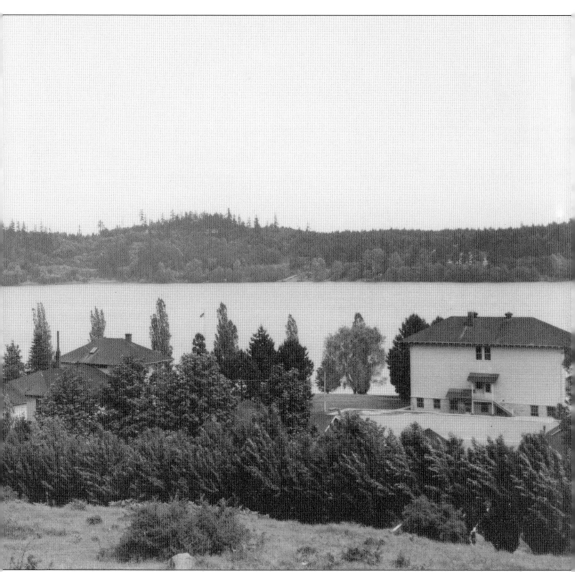

associated with the school as a teacher and a house parent, was appointed as superintendent. During Rand's 40 years of service, he supervised the expansion and development of the campus and contributed to the education and social needs of the children. (Courtesy Seattle Public School Archives.)

In 1912, Rand bought 80 acres from the Seattle School District for $15,000. In 1914, a hospital, laundry, and a large barn were built. Rand went on with his idea of developing a farm. Boys went half a day to school on the grounds, then spent the rest of the day on the farm. They gardened, fed the stock, picked apples, and milked cows. They developed a prize Holstein herd. (Courtesy Seattle Public School Archives.)

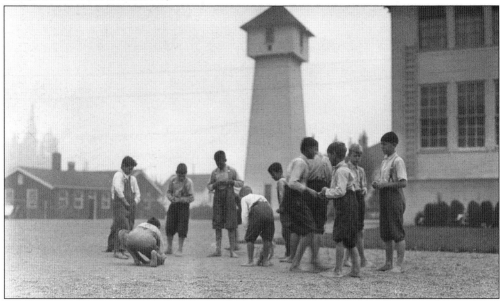

Over the next 36 years, Rand developed a thriving program of study and farmwork for 150 boys. James Johnson was hired as an agriculturist in 1915, and he supervised expansion to a self-sufficient farm of more than 100 acres. Cicero Newell's dream had been accomplished—to provide a home for boys and girls who had no one to look after them. (Courtesy Seattle Public School Archives.)

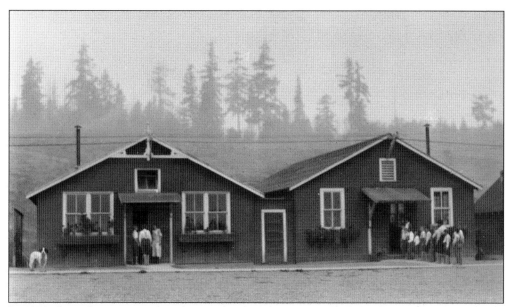

In 1914, the girls were transferred to a school of their own called Martha Washington School, located on the previous Paul Harper estate south of Seward Park. The name of the school was changed from Industrial School to Boys Parental School to avoid the stigma of a correctional institution. (Courtesy Seattle Public School Archives.)

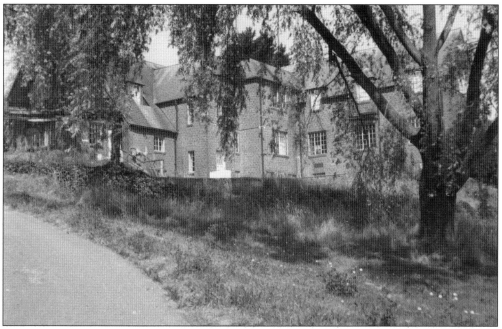

In 1929, a central heating plant and dormitory/classroom building were constructed; these are the brick buildings that remain today. In 1931, the name Boys Parental School was changed to Luther Burbank School after the California botanist famous for developing more than 800 new plants. In 1957, the State of Washington took over the operation of the school, and in December 1966, the students were moved to Echo Glen near Preston, Washington. (Courtesy Seattle Public School Archives.)

In 1968, King County purchased the site for $1.6 million and has since spent more than $2.5 million developing the property into a regional-class waterfront park. Money came from the Forward Thrust Bond Program, the interagency committee for outdoor recreation, and the state park and recreation commission. (Courtesy Seattle Public School Archives.)

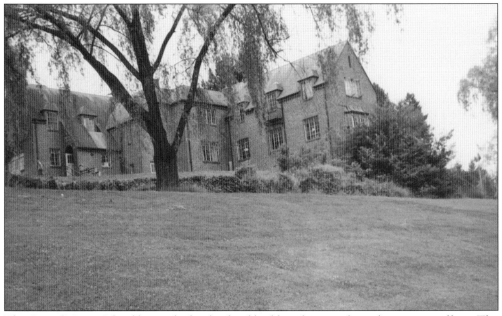

The City of Mercer Island leases the brick school building for its parks and recreation offices. The brick buildings were designed by Floyd Naramore, noted architect of many Seattle schools. Most of the park is still managed in its natural state, and the quiet observer can see pheasant, hawk, heron, kingfisher, muskrat, and salmon. (Courtesy Seattle Public School Archives.)

In 1965, the City of Mercer Island purchased this property and dedicated it as Groveland Beach Park. Originally, it was a Bible camp, used in the summer as a gathering place for religious groups, brought in mainly from off the island. Just over three acres in size, this beach park is located on the west shore of the island. (Courtesy Mercer Island Parks and Recreation Department.)

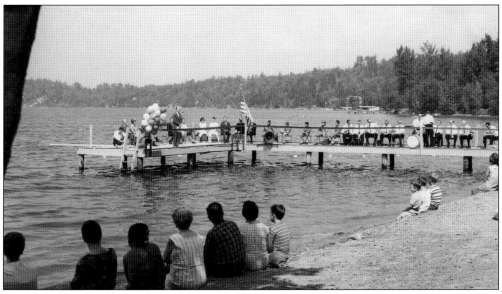

Groveland Beach is Mercer Island's largest public west-facing beach and a popular picnic area for families. The beach is sandy, and there are picnic tables, volleyball courts, and an open area for enjoying the scenic views. It also features a playground area above the beach, including swings and a children's jungle gym. (Courtesy Mercer Island Parks and Recreation Department.)

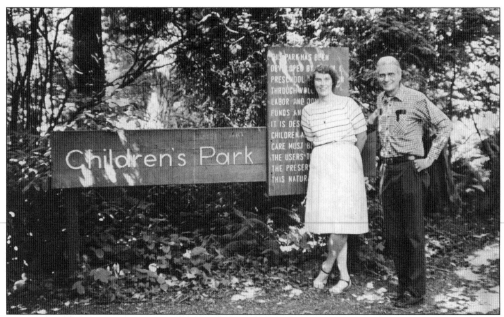

In 1962, Lola and Phil Deane were responsible for developing the "Dragon" Park, or Deane's Children's Park, as it is more properly known, in conjunction with the Mercer Island Preschool Association. They were very involved citizens and were honored at a Mercerversary Celebration in 1985 for their contributions to the community, drug prevention, and other youth activities. The Deanes were also owners of Island Books in the 1970s and 1980s. (Courtesy Mercer Island Parks and Recreation Department.)

The Mercer Island Preschool Association (MIPA) transformed a portion of Island Crest Park into Deane's Children's Park, a playground in a natural setting with a castle play structure, designed for children, ages three to eight. The dragon was added in 1966. The park was created through volunteer labor and donated funds and materials. (Courtesy Mercer Island Parks and Recreation Department.)

Dragon Park serves not only the children who attend the adjacent school—Island Park Elementary School—before, during physical education classes, and after, but it also serves the greater Mercer Island community. Thousands of young children grew up enjoying the dragon, climbing inside or on top of the colorful play structure. (Courtesy Mercer Island Parks and Recreation Department.)

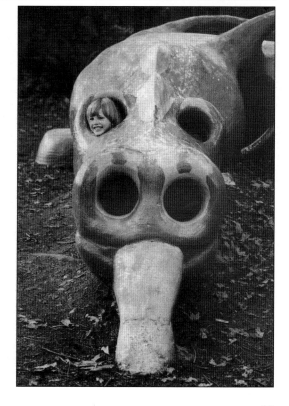

Mercer Island has a rich legacy of providing for the youngest members of its community. The first nursery school on the island was established in the 1920s. In 1937, Katharine McGilvra hosted the first meeting of what would become the Mercer Island Preschool Association. Over the years, MIPA has been a key part of community life on the island. (Courtesy Mercer Island Parks and Recreation Department.)

The City of Mercer Island Parks and Recreation owns 301 acres of open space, most of which is forested. This includes portions of properties identified as parks, such as this view of Ellis Pond, located at SE Forty-seventh Street and Ninetieth Avenue SE, for a total of 4.04 acres. The city has adapted an Open Space Vegetation Plan to manage these areas and keep nonnative plants from invading. (Courtesy Mercer Island Parks and Recreation Department.)

Clarke Beach was named for Mabel Clarke, the wife of Fred Clarke Sr. The Clarke family was one of the original pioneer families on the island, having arrived there in 1908. Mabel passed away in 1968 and was remembered for her sweet singing voice and her lifelong attention to growing things. Mercer Island Park director Bryan Snell moved the city to name its recently acquired south end waterfront park, "Mabel Clarke Beach Park." (Courtesy Priscilla L. Padgett.)

Pioneer Park, a 120-acre forest, was purchased by the City of Mercer Island in 1964. Ownership of the park was transferred to the Mercer Island Open Space Conservancy Trust in 1992. It contains 6.6 miles of trails. The park has been kept in a natural state so that island residents can easily get out in the woods. Roads divide the park into three distinct quadrants. (Courtesy Priscilla L. Padgett.)

In the early part of the 20th century, Pioneer Park was totally forested, and in the latter part of that century, there were several attempts to make it into a golf course. Citizens rallied to save the park, and the city council responded by creating the Mercer Island Open Space Trust in 1992. The trust was established to receive and hold in perpetuity all open space properties transferred to it by the city or others as approved by the city council. (Courtesy Priscilla L. Padgett.)

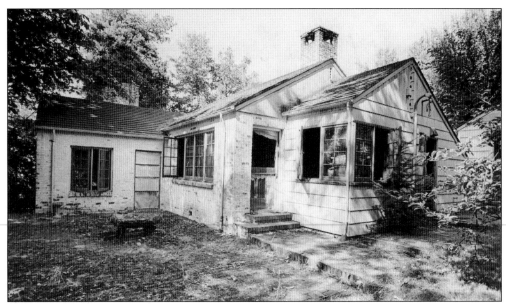

Pictured here is the old Slater homestead. The house was torn down to make way for a waterfront park in 1989. Harry and Loretta Slater formerly owned the property, which they willed to the city. Harry Slater had been the fire chief from 1948 to 1962 with the volunteer fire department, and in 1944, he was the island representative at the county library system meetings. (Courtesy Mercer Island Parks and Recreation Department.)

Slater Park is pictured here. In the background, the old Slater home is just visible. The property sits on Sixtieth Avenue SE, a stretch of road populated by mansions, as well as comparatively modest homes, all with views of Lake Washington, the floating bridge, and Seattle. (Courtesy Mercer Island Parks and Recreation Department.)

Seven

BUILDING A COMMUNITY

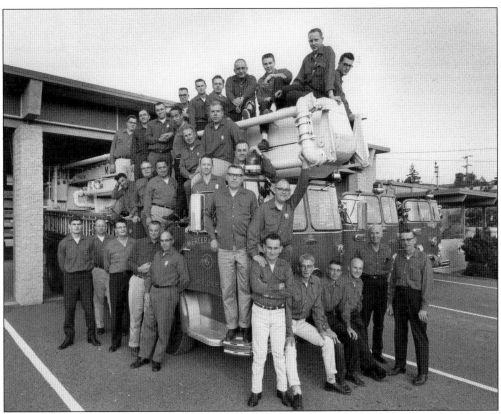

The Mercer Island volunteer firemen stand next to (or on) their carriage in this 1964 photograph. Volunteers include, from left to right, Gar Alm, Fred Alm, Thor Augustson, Bill Barnes, Ronald Becker, Earl Brower, Marvin Cross, Ronald Chase, Stuart Gould, William Green, Len Hammer, Carl Henrikson, Gayle Hilyer, William Hoell, Kenneth Kander, Henry Levinski, Howard Lightfoot, Robert Lightfoot, Cecil Little, Robert Look, Roy Lowe, Robert McCloskey, Nixon McHolland, Edward Maloof, Howard Pande, Albert Perret, Verne, Raught, Huston Riley, Joseph Robertson, Wayne Robinson, Edward Rock, Frank Sand, Marvin Sacquitine, Harry Slater, Rick Spickler, William Stanger, Harold Tate, John Waymire, Thomas Westad, Roger Wood, and Bruce Young. Earl Brower was the fire chief then. (Courtesy Thor Augustson.)

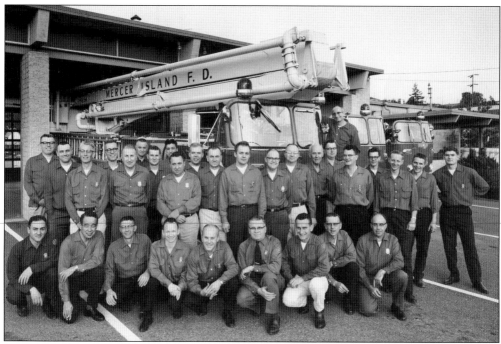

The Mercer Island volunteer firemen are pictured in 1964. By 1945, the fire commission had secured enough money to build the island's first fire station. Requests for the fire department's services were first provided via a telephone tree. Wives of volunteer firefighters would answer the home phone and pass along the request to other volunteer's wives. In 1955, it was apparent that a new fire station was needed. It was decided that the new fire station should be built at 3030 Seventy-eighth Avenue SE, site of the current headquarters. A second station was erected on the south end in 1961 and housed two fire engines. (Courtesy Thor Augustson.)

Thor Augustson sits in the front seat of his patrol car while he was on the police force in 1968. Augustson served on the Mercer Island Police Force from 1966 until 1994, when he retired. The mission of the Mercer Island Police Force is to contribute to Mercer Island's reputation as a safe, economically thriving community in which to live, work, learn, play, and visit. (Courtesy Thor Augustson.)

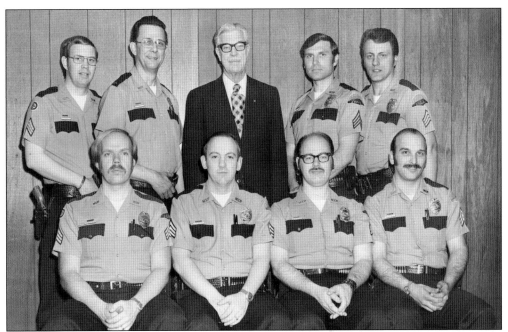

Thor Augustson (seated in the front row, left) is pictured with the Mercer Island Police Force in 1974. In those days, the police were focused on enforcement of criminal and traffic laws as well as investigating crimes. Nowadays, they also have a bicycle patrol in the central business district and I-90 corridor, and the marine patrol operates in the waters of Mercer Island, Medina, Renton, and Hunt's Point. (Courtesy Thor Augustson.)

The marine patrol unit promotes boating safety and education in all facets of their work, including boating enforcement contacts, educational literature, boating safety inspections, public presentations, and special events. Their boating program is mandated by the Washington State Parks and Recreation Commission to provide boating education to the public. The marine unit began on Mercer Island in the early 1990s. (Courtesy Mercer Island Police Department.)

Thor Augustson is seen here with his neighborhood friends and Cub Scout den in the mid-1940s. Cub Scouts is for boys in the first through fifth grades and provides a program that builds character, trains them in the responsibilities of participating in citizenship, and develops personal fitness. Cub Scouts enjoy service projects, games, skits, ceremonies, songs, crafts, and other activities. Augustson is pictured on the far right side. (Courtesy Thor Augustson.)

Dick Close, on the left, is shown in his Boy Scout uniform in this photograph. He achieved the rank of Eagle, requiring him to earn 21 merit badges, serve as a leader in the troop, go camping, hiking, and serve the community. All scouts aiming to become Eagles must also do a service project. Mercer Island's four troops have produced numerous Eagle scouts over the years. Close was a member of Troop 457. (Courtesy Ruth Mary Close.)

This monument represents all of the Eagle Scouts on Mercer Island from 1934 to 1985. There are over 200 Eagle Scouts listed on the monument. Dick Close, along with his brothers Dan and Frank, were all members of Troop 457 and they are all listed. Their father, Don Close, became an Eagle Scout with his troop in Laurelhurst, Seattle. Dick's nephew Dan O'Neill was also an Eagle Scout and a member of Troop 624. (Courtesy Steve Townsend.)

In the early 1930s and through the 1960s, Brownies and later, Girl Scouts, enjoyed a camp called Tarywood, located on the south end of Mercer Island. The camp was built on land donated by the Rotary Club. The camp was named Tarywood in honor of the Rotary Club. In this photograph, camp director Helena Johnson is checking in a Brownie, shown with her father. Johnson was the director of the camp for 12 years. (Courtesy Girl Scouts of Western Washington.)

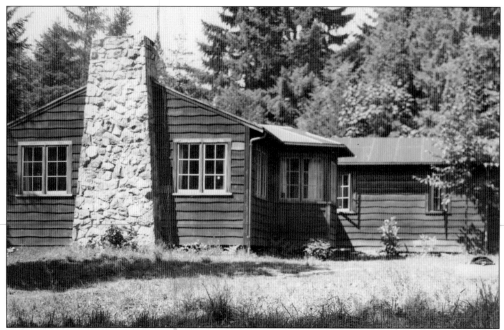

This is the lodge at Camp Tarywood. In 1933, ten acres on Mercer Island were donated by the Rotary Club. Lucille Henderson thought of the name Tarywood. The lodge was built in 1933, and the ferry *Dawn* brought troop campers to the island. In 1941, Tarywood became the first resident Brownie camp in the United States. The camp was first under the directorship of Dorothy Calvin, until 1945, when Helena Johnson took over. (Courtesy Girl Scouts of Western Washington.)

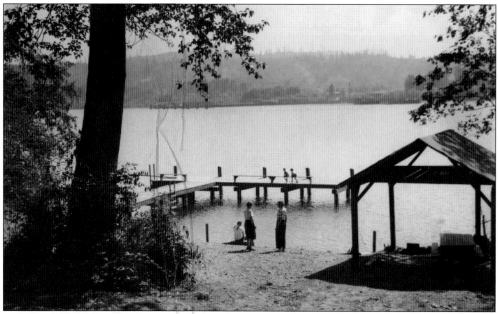

In 1939, proceeds of the cookie sale, garden parties, and a gift from Rosalind Clise were used to finance the purchase of seven acres of waterfront property. A dock was also built so that the girls could enjoy water sports. Between 1941 and 1944, fifty-nine Brownies attended four, one-week sessions. (Courtesy Girl Scouts of Western Washington.)

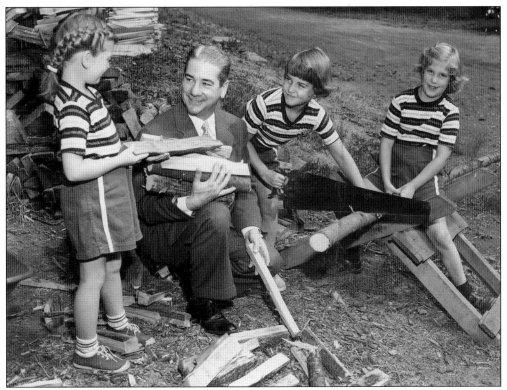

Nancy Naylor, George Weber, Caroline Hart, and Tanya Stromberg are gathering and sawing wood. The camp was very popular and always had a waiting list. In 1950, four hundred forty-three Brownies attended, and 500 were left on a waiting list. (Courtesy Girl Scouts of Western Washington.)

The camp curriculum was accepted nationally and used by other Girl Scout councils. In this way, it was established that Brownies between the ages of five to seven could attend camp under able leadership. After the land was cleared for buildings, the rest of the land was kept as it was, allowing for plant and nature studies. (Courtesy Girl Scouts of Western Washington.)

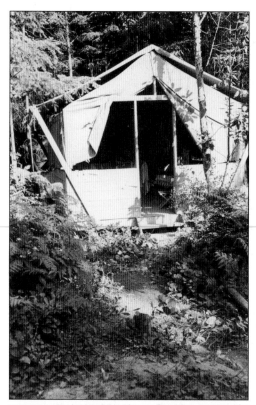

Before permanent cabins were built, campers slept in tent cabins. The remote area of the camp meant that there was a good assortment of native plants that had disappeared from elsewhere on the island. Beautiful stands of trilliums, wood fern, lady fern, and sword fern were prevalent. The site also had madrona trees, Douglas fir, red alder, red cedar, big leaf maple, western hemlock, Pacific dogwood, and willows. The girls made a salad using Oregon grape, elderberry, red huckleberry, thimbleberry, blackberry, and some black caps, all gathered from their surroundings. (Courtesy Girl Scouts of Western Washington.)

Screened cabins were added, accommodating four girls each. The camp program was flexible and leisurely, with the chief aim to learn to live happily in the outdoors. Activities included swimming, crafts, walks, dancing, drama, and exploring. The girls were under supervision at all times, and their counselors lived in cabins very close to the girls. (Courtesy Girl Scouts of Western Washington.)

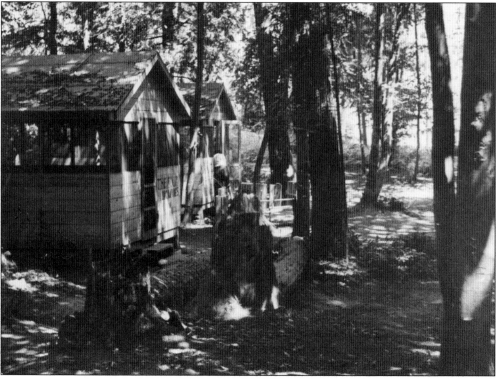

In 1944, the lodge was electrified, and a shower house was built, nicknamed "the Palace." A thousand girls used the camp for troop camping. In 1950, fees were raised, and the number of camping days increased to 10-day sessions. The cost was $26.50 for 10 days. In 1959, Mrs. Robert McCracken became the director, and the sessions changed back to seven days each. (Courtesy Girl Scouts of Western Washington.)

Fire circles were added in 1960, and waiting lists were still common. In 1962, many service projects were performed to clear the land of the damage it had received during a big storm. In 1963, the Seattle King Council dissolved and was replaced by the Totem Council. No Brownie Scouts were camping, and only second and third graders could camp. 1968 was the last year that a resident camp was operated at Tarywood. An additional 2,000 girls and adults used the site during the school year for activities such as troop camping and training courses. (Courtesy Girl Scouts of Western Washington.)

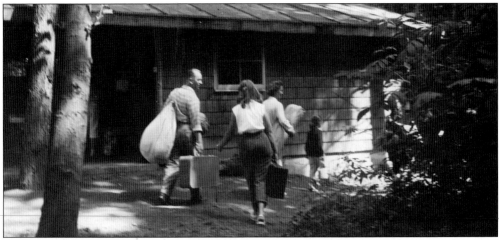

In 1969, Camp Tarywood was sold to the Mercer Island School District. With the encroachment of a nearby residential neighborhood, camp privacy was gone, and primitive camping was no longer feasible. The high school used the site for its prestigious Humanities Block. The city of Mercer Island bought a 1.3-acre waterfront portion of the camp earlier that year as a park. This was developed by the city and became Clarke Beach. Money from the sale of the camp was used to buy a new camp on Orcas Island. Developers purchased the site in 1984 for the purposes of building homes. (Photograph by McBride and Anderson, courtesy Girl Scouts of Western Washington.)

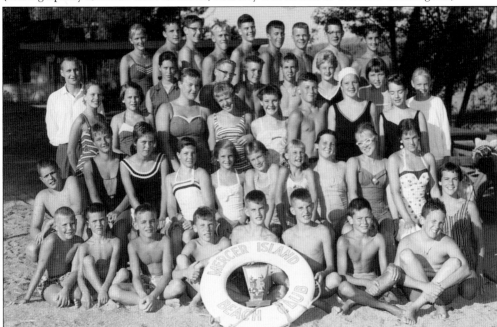

This 1957 photograph shows a swim team group shot at the Mercer Island Beach Club, a private club located on the south end of the island. It all began in the 1930s, when the Central Seattle Chapter of the Lions Club bought eight acres of waterfront on 625 feet of shoreline on the southeastern area, land that was granted earlier to the Northern Pacific Railway. A camp for underprivileged children was built. The camp era ended with the coming of the floating bridge, and the property was vacant until the south end club bought the property. (Courtesy Mercer Island Beach Club.)

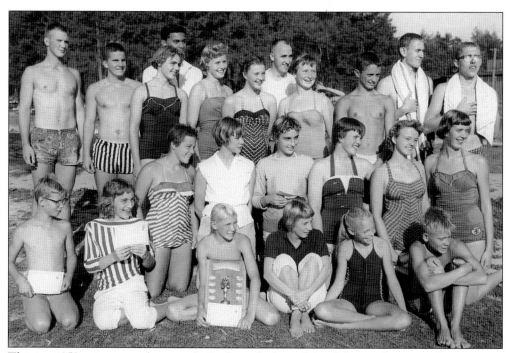

This is a 1958 swim team photograph. In the early days of the club, members agreed to continue swim lessons for all children until other parks were available. Then, a membership drive was begun. A table was set up outside Art's Food Center, and memberships were sold to anyone who lived, worked, or owned property on the island. (Courtesy Mercer Island Beach Club.)

Mercer Island Beach Club swim team members are pictured with their trophy from 1957. Members of the Beach Club felt they had achieved their goal of rescuing the property. The architecture was innovative at the time, as it was only the second building of its kind in this area. Only the remodeled caretaker's cottage is a reminder of the long-ago Lions Camp. (Courtesy Mercer Island Beach Club.)

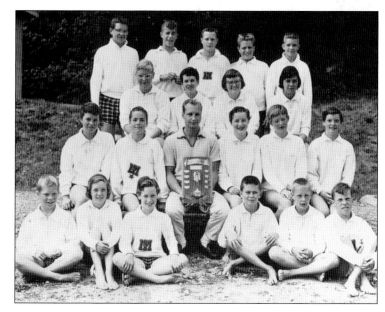

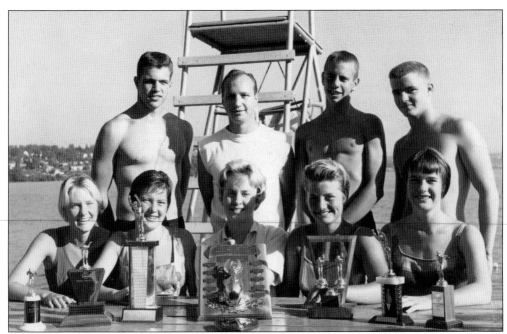

Members of the Mercer Island Beach Club staff are pictured here in 1961. The waterfront at the club includes the beach, lake swim area, swim dock, and moorage docks. The beach area includes a small tub of beach toys for castle building and a nearby lawn for sun tanning. The lake swimming area has lifeguarded hours during the summer months and is a popular location for members to cool off on a summer day. There is also a big slide, which is located on the swim dock. (Courtesy Mercer Island Beach Club.)

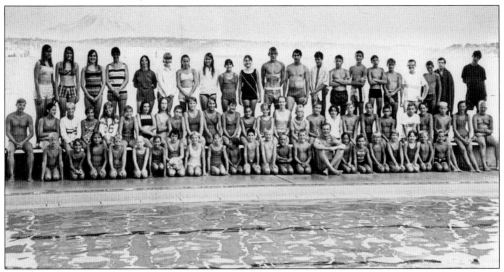

The Mercer Island Beach Club swim team is pictured here in 1967. The club today features two state-of-the-art pools designed for the whole family. The pools are set up to offer lap swimming, diving, or just playing. The activity pool also features the lazy river, which has a circular current that guides swimmers around "the river." The two pools are connected during the summer season (approximately May through October) and separated during the rest of the year. As part of their year-round swimming, the activity pool is covered by a bubble. (Courtesy Mercer Island Beach Club.)

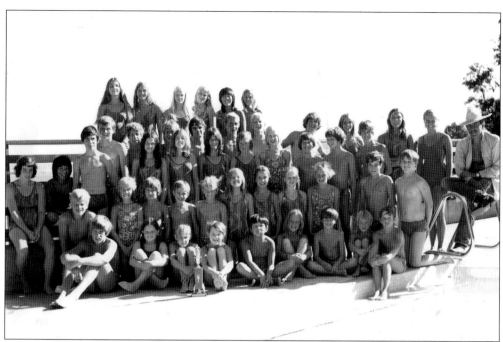

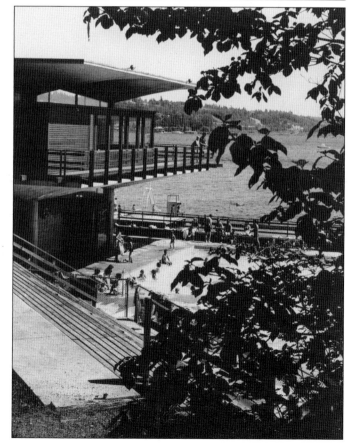

In this 1974 photograph, the swim team has grown considerably since the early days of the club, which now features a water polo team and a dive team. In addition, there are a wide variety of social events for members, including wine tasting, games, music, dancing, and a talent show. (Courtesy Mercer Island Beach Club.)

The club has gone through many changes: increased dues, improved moorage facilities, more tennis courts, dock, pool, and dance floor. It also offers a large rental space for parties and special occasions, which provides additional resources for the club. (Courtesy Mercer Island Beach Club.)

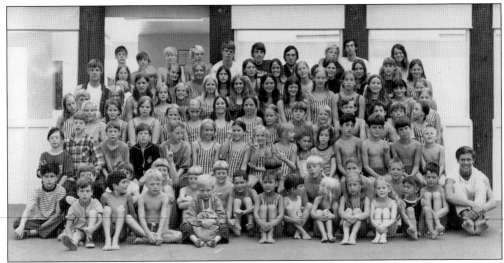

The Mercer Island Country Club is another social club on the island, offering swim and tennis memberships. The club began serving members in 1967. They offer seven indoor and eight outdoor tennis courts, an eight-lane 25-yard pool, a fully equipped cardio and weight facility as well as a group exercise studio. The swim team is pictured in 1971. (Courtesy Mercer Island Country Club.)

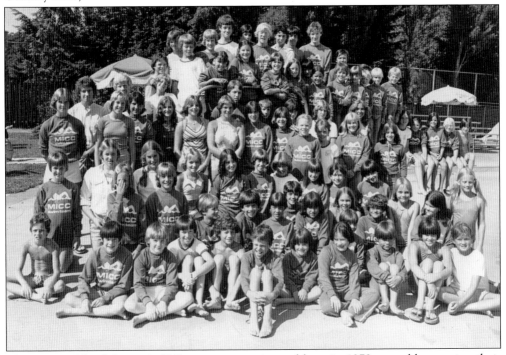

The Mercer Island Country Club swim team, pictured here in 1979, was able to enjoy their covered pool year round, thanks to the plastic bubble over it. South end members enjoyed the proximity to the adjacent shopping center, Islander Middle School, and Lakeridge Elementary School. Students are frequently seen with their tennis racquets sticking out of their backpacks after school or riding their bikes to the club on a hot summer day for a cool dip in the pool. (Courtesy Mercer Island Country Club.)

In 1969, the club raised a dome over its four tennis courts and swimming pool. The plastic bubble canopy, with flat ends, allowed club members to enjoy tennis and swimming in all kinds of weather and day or night. Bill Brown, who was club vice president at the time, said the tennis court canopy, held up by air pressure, was the only one of its kind in the world. (Courtesy Mercer Island Country Club.)

This bubble was unique at the time because it allowed in daylight due to its transparent consistency. The project cost over $135,000 and consisted of two canopies. The cover over the tennis courts was 35 feet high, 213 feet long, and 116 feet wide. A separate canopy, stretched over the entire swimming pool, was 102 by 112 feet. A 22-foot long alcove connected the two canopies. (Courtesy Mercer Island Country Club.)

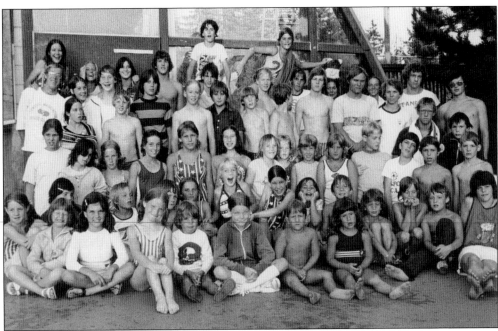

The swim team is pictured here in 1970. As the club grew, they not only offered swim and tennis teams, but dive and water polo teams as well. The swim, dive, and water polo teams compete in the Midlakes League. The junior tennis team competes in the Junior Eastside League. An eight-week summer kids' camp is popular with weekly themed activities. (Courtesy Mercer Island Country Club.)

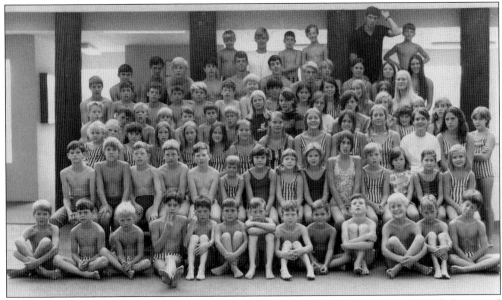

This 1969 photograph shows the swim team. The club had a large swim team, and that trend continues to the present day. Year-round swim lessons, tennis lessons, junior swim team, and junior tennis team are available. The Mercer Island Country Club sponsors men's, women's, and mixed teams to compete in United States Tennis Association (USTA) league tennis, women's teams for competitive local cup play and men's team tennis. (Courtesy Mercer Island Country Club.)

Nowadays, the club offers fitness programs such as cardio mix, boot camp, yoga, and swimming. Social events occur year round at the country club, including the summer kick-off party, summer tennis tournament, cookie decorating party, wine and cheese party, bridge, knitting group, and family fun nights. (Courtesy Mercer Island Country Club.)

The Mercerwood Shore Club, located on the northeast shore of Mercer Island, began in 1953. In this photograph, the club is under construction. The brick building in the background was constructed in the 1930s by the Lutheran Church, where social services were available to members. Later, during World War II and after, it became a home for unwed mothers. (Courtesy Mercerwood Shore Club.)

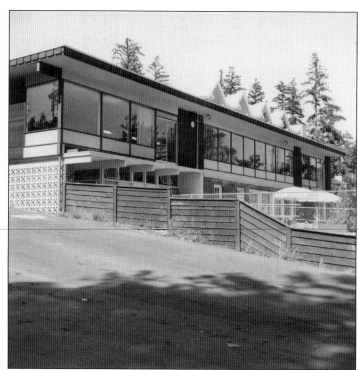

The clubhouse, pictured in 1965, with its sweeping view of Lake Washington and Mount Rainier, provides excellent facilities for members' enjoyment of indoor social activities, including dances, parties, receptions, and meetings. The club contains a large dance floor, lounge, kitchen, game room, snack bar, and dressing rooms. The clubhouse is available for private usage on a rental basis. (Courtesy Mercerwood Shore Club.)

Jamilee Kempton and Chuck Wotipka are shown playing in a junior mixed doubles tournament from 1977. Tennis is played year round on four Laykold courts. During the spring and summer months, organized activities include junior tennis development and junior team programs, ladies day, and interclub doubles competition, men's evening and Saturday morning doubles, evening mixed doubles, private and group lessons, clinics, ladders, and tournaments. (Courtesy Mercerwood Shore Club.)

Pictured here is the pool under construction in 1959. It was an Olympic-size outdoor pool, complete with both one-meter and three-meter diving boards. During the summer season, the club offers competitive swimming, diving, and water polo teams. The Mercerwood Shore Club Swim Team and Mercerwood Shore Club Water Polo Team have been reigning Midlakes champions for years. (Courtesy Mercerwood Shore Club.)

The waterfront facilities include a swimming beach, water ski beach, dock, picnic and children's play area, a boat ramp for launching boats for day sailing and cruising, and moorage slips for 36 boats up to 24 feet in length. Moorage is available on a seasonal basis at a moderate cost. (Courtesy Mercerwood Shore Club.)

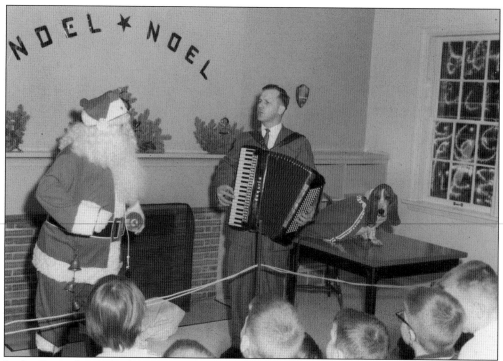

In this December 1960 photograph, unknown club members are shown at a club Christmas party. The club was a central part of many members' social lives, offering gatherings and get-togethers of all kinds for kids, teens, and adults. Today, the clubhouse is a 6,000-square-foot year-round event facility featuring a weight room, cardio studio, and a full calendar of social and fitness programming. (Courtesy Mercerwood Shore Club.)

The club served as a social networking hub, with bowling and other activities besides swimming and tennis that were organized for the members' benefit. In this 1964 photograph, from left to right, Fran Haywood, Ann Otis and Shirley Foley are shown with their bowling balls on a girls' night out with the Mercerwood Bowling League. (Courtesy Mercerwood Shore Club.)

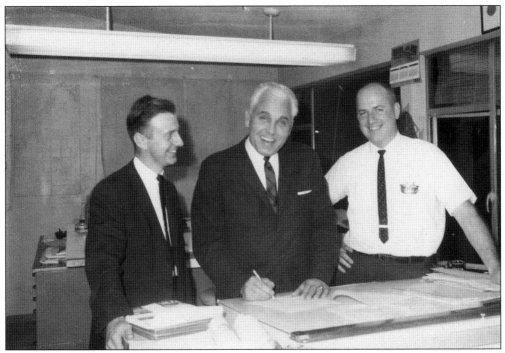

In 1965, Duane Ruud, Richard Smith, and Doug Weeks are discussing the swimming pool cover. Ruud was with the industrial products division of Seattle Tent and Awning, Smith was the president of Mercerwood Shore Club, and Weeks was an engineer. (Courtesy Mercerwood Shore Club.)

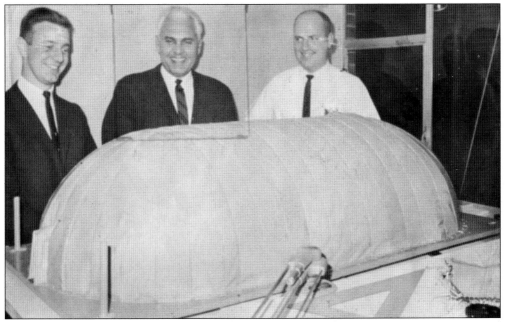

Also in 1965, Ruud, Smith, and Weeks are shown with a model of the swimming pool cover, which was purchased from Seattle Tent and Awning. After the pool cover was in place, members could swim in the winter months while avoiding the outside elements. (Courtesy Mercerwood Shore Club.)

This 1965 image of the Mercerwood Shore Club shows the tennis courts, clubhouse, and view of the lake. A private, family-oriented sport and recreation facility, it sits on six acres with 500 feet of Lake Washington waterfront. (Courtesy Mercerwood Shore Club.)

The Stroum Jewish Community Center (SJCC) was founded in Seattle in 1948 and constructed a new building on the island in 1967. There is a wide spectrum of activities offered to the general public, and it is not limited to members of the Jewish faith. Included in areas of social, cultural, and recreational activities are programs for all ages. (Courtesy Stroum Jewish Community Center.)

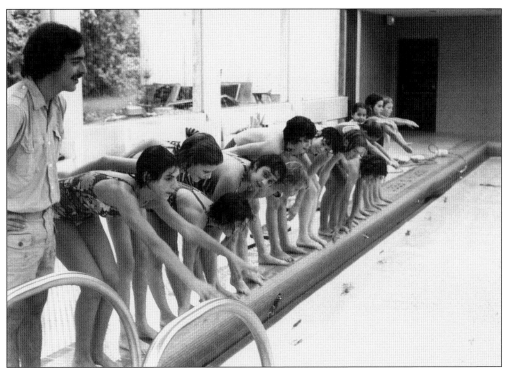

Outstandingly popular are preschool child care with structured learning, summer day camps, theatricals, swimming, art exhibits, and health clubs. At least 130 classes are offered; attendance in one month is about 20,000. In 1981, a building program doubled the center's size to 90,000 square feet. (Courtesy Stroum Jewish Community Center.)

The Stroum Jewish Community Center (SJCC) is a cultural center as well. It gives people the opportunity to go and reaffirm their Jewish identity. It was and is a good place for people to come together, especially those who are not connected to the Jewish community. (Courtesy Stroum Jewish Community Center.)

Founded in 1949, the SJCC is dedicated to the enrichment of the Jewish and non-Jewish community in the greater Seattle area. The SJCC offers diverse programming that includes community-wide events, a premier early childhood school, parenting center, summer day camp, school's out program, before- and after-school care, sports leagues, activities for adults and seniors, and a variety of social, cultural, and recreational programs. (Courtesy SJCC.)

The Mercer Island SJCC has served the Jewish and non-Jewish community since 1968. This location includes a fitness center, racquetball courts, indoor running track, gymnasium, and an indoor swimming pool. It also has an auditorium, a children's library, kitchen, classrooms, and meeting rooms. (Courtesy SJCC.)

More than 10,000 people pass through the doors of the SJCC Mercer Island campus each year, and more than 200 children are enrolled in its infant, toddler, preschool, and kindergarten programs. Each year, the SJCC offers programs ranging from swimming lessons to parenting lectures and yoga classes. It also offers transportation to and from several Mercer Island and east side elementary schools for its before- and after-school program. (Courtesy SJCC.)

Summer camps include arts, sports, drama, teen adventure, and traditional Jewish day camps with transportation available. Examples of community-wide events include the annual Hanukkah celebration, Purim Carnival, Sukkot celebration, and Second Night Passover Seder. The auditorium, rooms, and kitchen are available for rental groups, including birthday parties. (Courtesy SJCC.)

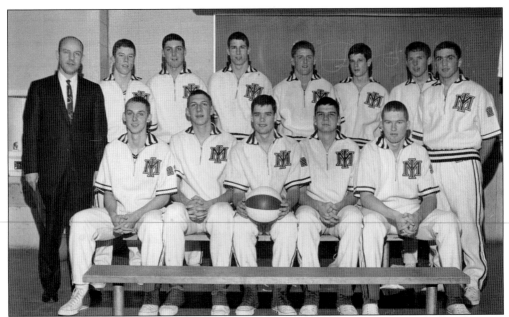

Ed Pepple is shown with the Mercer Island High School (MIHS) basketball team in 1968. Pepple coached at MIHS from 1968 to 2009, earning 23 league championships with the overall winningest record in state high school basketball with 882 wins. Ed Pepple was an institution at the high school and much loved by his players. (Courtesy Ed Pepple.)

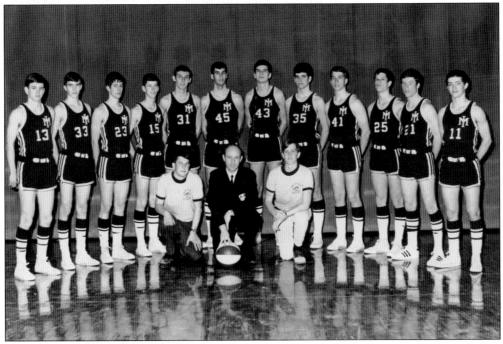

Pepple is pictured here with his Mercer Island High School varsity team in 1969. Pepple has collected numerous honors and awards over his career, including the Naismith Memorial Hall of Fame Morgan Wootten Award for Lifetime Achievement in coaching high school boys' basketball in 2012. (Courtesy Ed Pepple.)

Some of Ed Pepple's other awards include the Mercer Island Hall of Fame (inducted on September 10, 2010) and the National Federation of High School Associations Hall of Fame in 2010. The Mercer Island gym was dedicated to Shirley and Ed Pepple in 2010. (Courtesy Ed Pepple.)

In this 1993 photograph, Coach Pepple and his team celebrate their AAA State Championship win, one of several state championship wins that Pepple's teams achieved. In 2009, the Washington Interscholastic Basketball Coaches Association (WIBCA) established the Ed Pepple Coaches Service Award, to be presented annually to a member of WIBCA for service to the Washington State basketball community. (Courtesy Ed Pepple.)

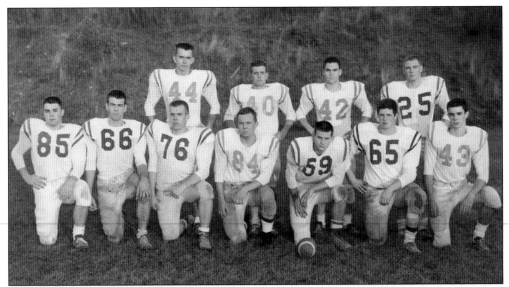

Thor Augustson is third from the left in the front row of this 1955 photograph of the Mercer Island High School football team. Mercer Island High School opened in 1955 and quickly earned a reputation for excellence in academics as well as sports. Today, MIHS academically ranks as one of the top schools in the state, and their sports teams consistently rack up championship wins and accolades. (Courtesy Thor Augustson.)

The Shorewood Apartments were built in the 1950s by Charles Clise during a time of rapid growth on the island. Clise built eight buildings on the lakeshore, with a total of 116 apartments. This area was called Lower Shorewood. Upper Shorewood was built next, with a total of 38 buildings and 568 apartments. For 25 years, the apartments were owned and operated by Clise. (Courtesy Priscilla L. Padgett.)

After Clise passed, the complex was purchased by a developer who went bankrupt, was owned by a mortgage company, and finally purchased by the Covenant Retirement Communities, based in Chicago. They changed it into a retirement community through extensive remodeling and updating. The old dance hall, once part of Fortuna Park, was transformed into the dining facility and is affectionately known as "the Lodge." (Courtesy Priscilla L. Padgett.)

Stanley Dunham's parents moved to Mercer Island in 1955, attracted by the new high school that had just opened and the new apartments nearby, known as the Shorewood Apartments. The offices of city hall were located at Shorewood from 1961 to 1989, when they moved to the new city hall location at 9611 SE Thirty-sixth Street. (Courtesy Priscilla L. Padgett.)

Mercer Island High School, opened in 1955, has earned numerous awards over the years. In 2006, MIHS received the prestigious Blue Ribbon Award from the US Department of Education, the criteria of which is based on students consistently achieving in the top 10 percent on the High School Proficiency Examination. The *Seattle Times School Guide* rated MIHS the no. 1 public high school in Washington for quality of preparation of students. (Courtesy Priscilla L. Padgett.)

The ladies from the show *Pirates of Penzance*, a musical from the Mercer Island High School drama program, are pictured in the mid-1980s. The drama department has been entertaining audiences for years and is known for putting on great productions. Students have consistently earned honors from Seattle's 5th Avenue Awards, an event held annually by the 5th Avenue Theatre, to honor the work, talent, and commitment that students, parents, and faculty devote to their school's annual musical productions. (Courtesy Mercer Island High School Drama Department.)

Prior to 1976, the Mercer Island band averaged about 30 members through its formative years. The community of Mercer Island wanted to improve the music program and so formed the Mercer Island Music Advisory Committee. The band program steadily grew to over 300 members in 2010. Currently, almost one in every four MIHS students is enrolled in the band program. Under the leadership of directors Parker Bixby, Ryan Lane, David Bentley, and Carol Krell, the MIHS band has experienced great success at both a local and international level, receiving numerous awards and accolades. They performed in the 2006 and 2012 Tournament of Roses Parade and the 2011 London New Years Day Parade. (Courtesy Priscilla L. Padgett.)

Mercer Island's summer celebration kicks off with an annual small-town parade, usually on a sunny Saturday in July. The events of the three-day weekend include a parade, carnival, crafts booths, food booths, entertainment for kids and adults, boat cruises, garden tours, theatrical events, a three-on-three basketball tournament, and a gigantic fireworks display to cap it all off. (Courtesy Charles A. Padgett.)

DISCOVER THOUSANDS OF LOCAL HISTORY BOOKS FEATURING MILLIONS OF VINTAGE IMAGES

Arcadia Publishing, the leading local history publisher in the United States, is committed to making history accessible and meaningful through publishing books that celebrate and preserve the heritage of America's people and places.

Find more books like this at
www.arcadiapublishing.com

Search for your hometown history, your old stomping grounds, and even your favorite sports team.

Consistent with our mission to preserve history on a local level, this book was printed in South Carolina on American-made paper and manufactured entirely in the United States. Products carrying the accredited Forest Stewardship Council (FSC) label are printed on 100 percent FSC-certified paper.

MADE IN THE
USA